Learn to Paint

LIGHT
IN WATERCOLOUR

John Lidzey

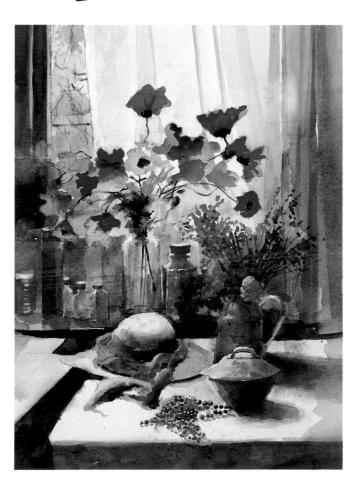

HarperCollins*Publishers*

DEDICATION

To my wife

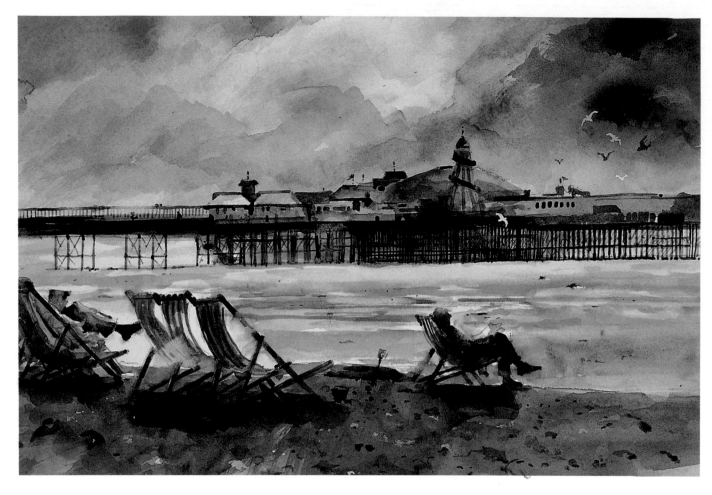

First published in 1997 by
HarperCollins*Publishers*, London

97 99 01 02 00 98
1 3 5 7 9 8 6 4 2

**A catalogue record for this book is
available from the British Library**

Editor: Diana Vowles
Design and Typesetting: Caroline Hill
Photographer: Douglas Atfield

ISBN 0 00 412963 6

Colour reproduction by Colourscan, Singapore
Printed and bound in Italy by Rotolito
Lombarda SpA, Milan

PREVIOUS PAGE:
Studio Still Life
43 × 28 cm
(17 × 11 in)

THIS PAGE:
On the Beach
26.5 × 43 cm
(10½ × 17 in)

OPPOSITE:
Flowers in a
Copper Mug
15 × 25.5 cm
(6 × 10 in)

CONTENTS

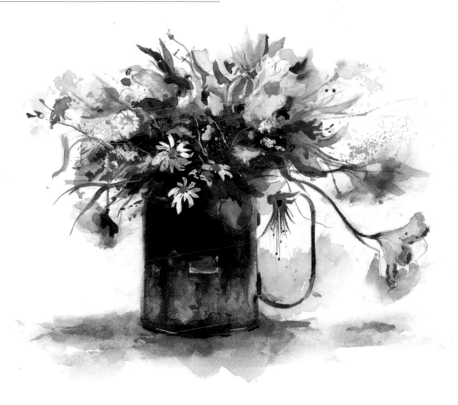

PORTRAIT OF AN ARTIST
JOHN LIDZEY

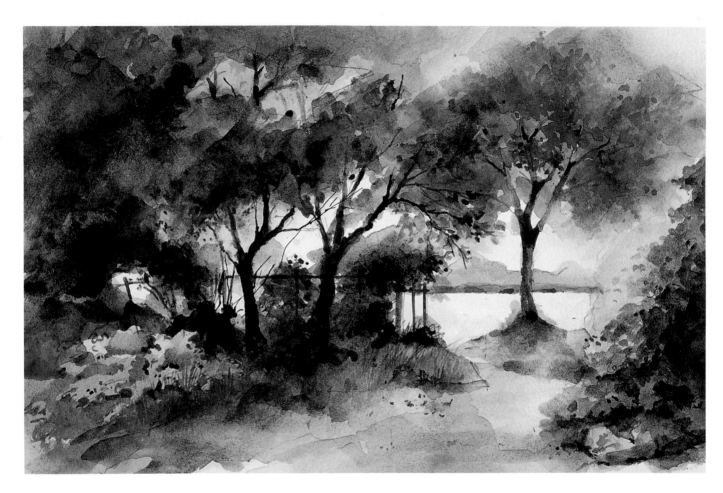

John Lidzey studied typographic design at Camberwell School of Arts and Crafts and then began his working life in an advertising studio. There he was considerably impressed by the work of the visualizers, who used felt nib markers, paints and pastels to create exhilarating drawings which formed the bases of advertisements and television commercials. After leaving advertising he worked for art studios and design groups for 10 years, during which time he became a member of the

Society of Industrial Artists and won design awards.

In the late 1960s John returned to Camberwell School, this time as a lecturer in typographic and graphic design. It was during this period that he began to take an interest in watercolour painting, and in his explorations in the medium he sought to express himself with the freedom and vitality that he had admired so much at the advertising studio. He would frequently spend an hour early in the morning sketching the

▲ View from the Gate
23 × 33 cm (9 × 13 in)
This painting shows the outlook from John Lidzey's garden; he considers himself fortunate to have such accessible subject matter.

London streets before arriving at college, and still maintains that sketching and painting every day is the best way to develop real skill with watercolours.

John's work began to find a growing market and in the late 1980s he decided to devote himself to painting. He moved to the Suffolk countryside and there set up home in a Victorian house which is the subject of most of his interiors. In 1990 he won the Daler-Rowney Award at the 1990 Royal Watercolour Open Exhibition and in 1992 he was a prizewinner in the Singer Friedlander/Sunday Times Competition, exhibited at the Mall Galleries in London. In 1993 he became a fellow of the Royal Society of Arts. His work is widely admired for its fresh, loose quality, and his paintings are in collections in the UK, the USA, Europe and Australia. He exhibits in London, Suffolk and the Cotswolds.

Since leaving full-time teaching John has conducted workshops in London and Birmingham and has run weekend watercolour courses from his studio in Suffolk, demonstrating his techniques and painting with his students in the surrounding countryside. His earlier books are *Watercolour Workshop*, for which he produced an associated video, and *Mix Your Own Watercolours*. He also contributes articles to the magazines *Artists & Illustrators* and *The Artist*.

THE PAINTING OF LIGHT

The presence of light, either natural or artificial, does not only enable us to see our surroundings, but also governs the exact appearance of objects at any given moment. When we make a visual error and identify something wrongly we often use the expression 'it was just a trick of the light', and indeed the way light shines on objects can often make them look like something else altogether.

If light has the capacity to deceive us, it also possesses the power to amaze. We have all experienced the magical effects that sunlight can provide: a beautiful sunset at sea, for example, the sun shining through the leaves in a wood, and even early-morning sunlight slanting across a city street.

Inside buildings also, light can have a breathtaking quality. Factories, churches, railway stations, greenhouses and atria all provide unusual lighting qualities which can interest anyone who paints.

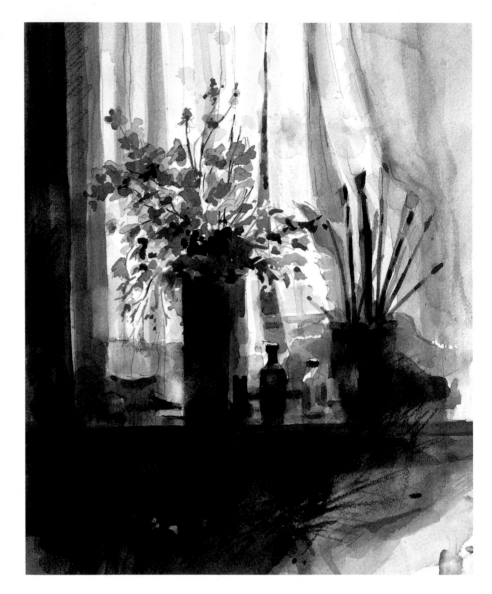

▲ Flowers in the Studio
24 × 20 cm (9½ × 8 in)
An untidy windowsill by my desk makes a good subject for an against-the-light painting. I haven't made any effort to paint details as my concern was to suggest the quality of light in the subject.

MOOD AND ATMOSPHERE

Light and shade can have a powerful effect on the emotional content of a scene. For example, bright daytime sunshine and luminous colours in a landscape create feelings of well-being and optimism. However, as the sun gets lower, the light fades and shadows lengthen, the mood in the landscape changes. A scene can take on a quiet and nostalgic air and details become lost in shadow. Catching the visual effects afforded by late-evening sunshine can result in very rewarding watercolours that are perhaps more effective than those produced under bland midday light.

In interiors, too, lighting can affect the mood. Low and localized lighting from table lamps, candles or even firelight can create an air of warmth and comfort. Harder lighting can alter the mood completely – for example, a solitary lightbulb illuminating a bare room can evoke feelings of fear and menace. You may be familiar with Pablo Picasso's *Guernica* (1937), where a single lightbulb is used symbolically to reveal the horrors of the Spanish Civil War.

Your own painting of interiors may well be more serene, yet whatever lighting you choose its position is important. Low lighting where shadows are cast upwards often looks sinister, while lighting from above can look bland. In many cases you will find that a single source of illumination carefully placed at table-top level will create interesting lighting and suggest a mood of ease and serenity.

WATERCOLOUR AND LIGHT

Watercolour is particularly suited to catching the effects of light and shade as the translucent nature of the pigments together with the purity of the colours creates a luminosity unrivalled by any other medium. But bringing out these qualities and creating the effects of freshness and spontaneity cannot be achieved without application and practice. The following pages of this book will give you practical guidance on how to capture light in watercolour. I hope it will be useful and that the step-by-step demonstrations will provide inspiration for you to plan and develop your own paintings with confidence and enjoyment.

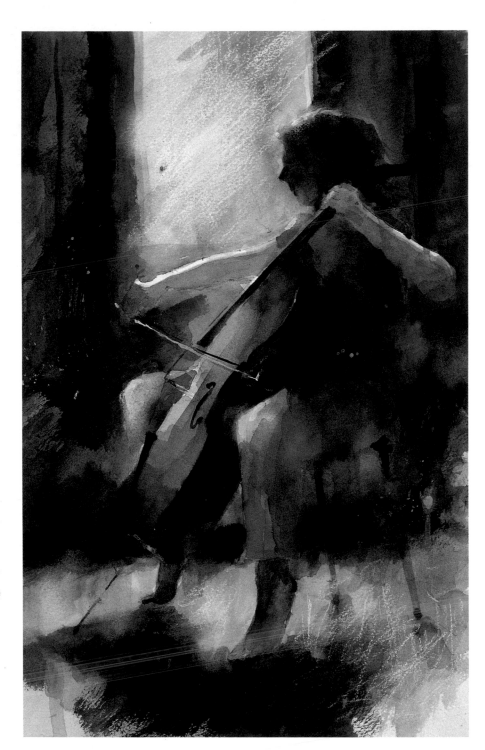

▲ Anna Playing the Cello
41 × 26 cm (16 × 10¼ in)
I painted Anna against the light from a window, which meant that much of the figure was in shadow. Working this way can provide strong contrasts and interesting shapes.

MATERIALS AND EQUIPMENT

◀ *A slim metal paintbox useful for working on location.*

It is possible to buy watercolour paints, brushes and paper very cheaply at many stationery shops. However, far from being a bargain, such materials are invariably of poor quality and will give you unsatisfactory results. It is much better to buy the best that you can afford from a reputable art store.

COLOURS

Watercolour paint is obtainable in pans or tubes. If you prefer your paint in a convenient form a paintbox with pans of colour is best, especially when painting on location. However, pans are not normally suitable if you wish to produce large paintings where plenty of colour needs to be generated.

Tubes of watercolour contain paint in a more fluid form and are probably more suitable for studio use. Although tube colour is better for covering large areas of paper it tends to be less economical as it is all too easy to waste paint by squeezing out more than is actually needed.

Watercolour paints can be obtained in two grades: Artists' Quality and Student Quality. The former contain good, finely ground pigments and represent the best available in a paint manufacturer's range. They are well worth buying if you want to achieve a satisfactory tone and intensity of colour. In the manufacture of Student Quality paints compromises are made: cheaper pigments are often substituted for expensive ones and the quantity of pigment may be reduced, to be replaced by fillers and extenders. You should only purchase these paints if you cannot afford the better quality.

SELECTING YOUR COLOURS

It is surprising how many colours can be mixed from a small number of pigments; with no more than 10 or 12 it is possible to match nearly all of the colours seen in nature. The paints shown right will suit most, if not all, of your needs.

A further useful addition to your painting kit would be a tube of Permanent White or Titanium White gouache.

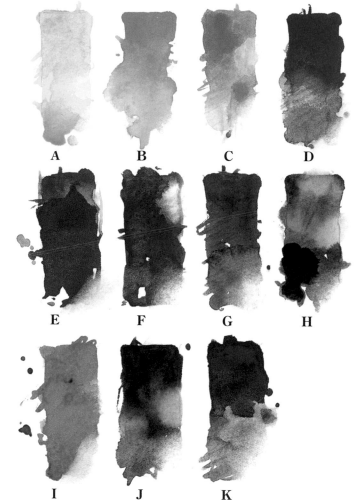

A B C D

E F G H

I J K

◄ Colour Chart
A Aureolin
B Cadmium
 Yellow Deep
C Yellow Ochre
D Permanent
 Red
E Crimson
 Alizarin
F French
 Ultramarine
G Monestial Blue
H Indigo
I Viridian
J Payne's Grey
K Burnt Umber

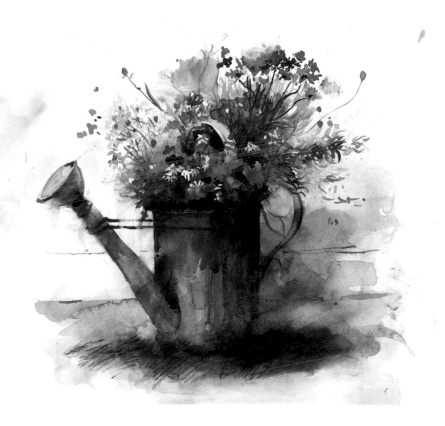

◄ A Watering Can of Flowers
25.5 × 27 cm (10 × 10½ in)
This well-worn watering can with flowers gathered from the garden makes an interesting subject. I used white gouache both on its own and mixed with watercolour pigments to suggest much of the detailing of the flowers and foliage.

9

PAPER

The range of watercolour papers available is large. The most expensive are made by hand from 100 per cent cotton rag, while cheaper papers are made by machine. These are known as mould made. Watercolour papers are specially treated so they will accept water-based pigments, though some absorb paint far more readily than others, the degree of absorbency depending on the type and amount of sizing the paper receives.

If you are a newcomer to watercolour you will probably find that one of the less expensive well-sized mould made papers is best suited to your needs. On such papers the paint tends to remain on the surface, allowing corrections to be made while the paint is still wet.

PAPER WEIGHT

It is standard practice to refer to papers by their weight rather than their thickness. There are two ways of describing the weight of a piece of paper: lb per ream (500 sheets) or gsm (grammes per square metre). Watercolour paper is usually available in Imperial size sheets, which measure 56 × 76 cm (22 × 30 in). The weight of a ream of paper usually determines the thickness of the individual sheets, so in a ream of Imperial paper weighing 90 lb the sheets would be thinner and less substantial than in one weighing 300 lb. The metric equivalent of lb per ream, gsm, expresses weight in terms of the number of grammes in a square metre of paper.

The most popular weight with watercolourists is 300 gsm (140 lb) paper. If you want to

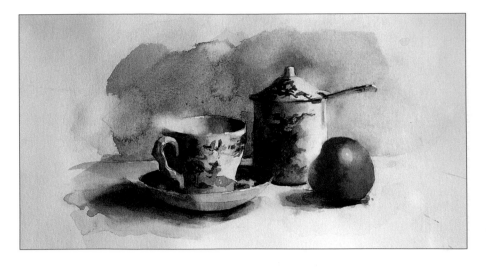

▲ Hot Pressed (HP) surface ▼ Cold Pressed (or Not) surface

use this weight of paper for a half-Imperial size painting (56 × 38 cm/22 × 15 in) or larger it will need stretching (see opposite page). Below this size it can normally be used taped to a board with masking tape.

PAPER SURFACE

The surface texture of the watercolour paper you use can have a marked effect on the final look of the painting. Many papers are available in three alternative surfaces.

Smooth or Hot Pressed (HP)

This paper has no surface texture. It tends to have a slight

▼ Rough surface

waxy sheen which is lost when it is immersed in water prior to stretching. It can be used for work requiring fine detail.

Cold-Pressed or Not This paper has a slight texture and is the most popular as the roughness of the surface makes the paint easier to control. (The word 'Not' means not smooth and not rough.)

Rough As you would expect, this paper has a coarse, lumpy texture. Paint brushed over its surface will often only partially cover the paper, creating a speckled or uneven result, while lightly painted lines achieve a broken quality. It is better to gain experience with other papers before working with this more difficult surface.

PADS OF PAPER

Many papers made in sheet form are also available as pads, which provide an easy alternative to using stretched paper. However, lightweight papers will always buckle, so make sure that the pad you purchase contains paper of suitable weight.

STRETCHING PAPER

Light- and medium-weight papers will need to be stretched when used in any size larger than 38 × 28 cm (15 × 11 in) in order to prevent the paper from buckling during painting. Buckling causes washes to lie unevenly on the surface and also creates difficulties when painting fine detail.

MATERIALS REQUIRED FOR STRETCHING

1 A piece of board 10 cm (4 in) larger than the paper you intend stretching.
2 Brown gumstrip paper 50 mm (2 in) wide.
3 A small sponge and a container of clean water.
4 A sharp knife or a pair of good scissors.

PROCEDURE

Cut pieces of gumstrip slightly longer than the dimensions of the paper. Soak the paper in water for 15 seconds – a bathtub or a large sink is the best place in which to do this. Remove the paper and allow the surface water to drain off it. Lay the paper on the board and smooth it flat, removing any creases or air bubbles.

Moisten each piece of gumstrip with the sponge and place it over the edges of the paper, smoothing the gumstrip flat to ensure that contact is complete. When this is done trim the gumstrip to length and leave to dry completely. The paper may buckle slightly after the gumstrip has been applied but this will completely disappear as drying proceeds.

▲ *Stretching paper*

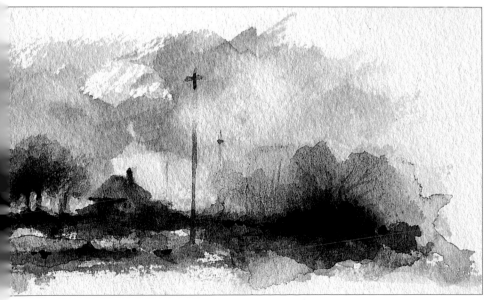

▲ *Make sure you tighten all bottle lids so that the contents do not dry up.*

BRUSHES

The quality of your brushes should be your most important consideration. A good brush will be well-shaped, and it will keep that shape. Moreover, it will last longer than cheaper brushes.

The best brushes are made from pure Kolinsky sable hair, such as the Diana Series made by Daler-Rowney. They are expensive, but well worth the money. Daler-Rowney's Series 34 brushes are made from cheaper sable hair and give good value; alternatively, if your funds are limited, the Dalon range of artists' brushes Series D77 can be recommended. They are made of man-made hair but effectively imitate the qualities of natural sable. The basic watercolour brush is known as a Round brush. The best sizes to have for general work are 2, 4 and 8. Another very useful purchase would be two mop brushes, 18 mm (¾ in) and 10 mm (⅜ in). These are good for painting flat washes and are relatively cheap to buy.

PALETTES

Metal paintboxes incorporate palettes for mixing paint, but these are often inadequate. For mixing generous quantities of paint a number of china palettes are useful; failing this, you can simply use ordinary cheap white tea plates. For tube paints, large plastic palettes containing mixing wells with separate areas for squeezing out colour are available.

DRAWING BOARD

In order for you to work effectively your watercolour paper must be attached to a drawing board. If you intend working out of doors you will need one that is light and portable. I often use a piece of hardboard 10 cm (4 in) larger than my paper for this purpose. Medium Density Fibre Board (MDF) is more substantial and also good to use. If you are stretching paper, do not use a board which is melamine-faced as gumstrip will not stick to it.

EASEL

Some watercolourists invariably use an easel when painting on location, though I prefer to hold the drawing board and tilt it this way and that as I paint because it gives me greater control over the flow of watercolour on the paper. If you feel you would like to use an easel, make sure you buy one that is both sturdy and portable. There are a number of different wooden or aluminium models on the market which should satisfy your needs.

DRAWING EQUIPMENT

If you are making a preparatory pencil drawing on watercolour paper, use a 2B or 3B pencil if you do not wish the pencil marks to be obtrusive. Softer materials

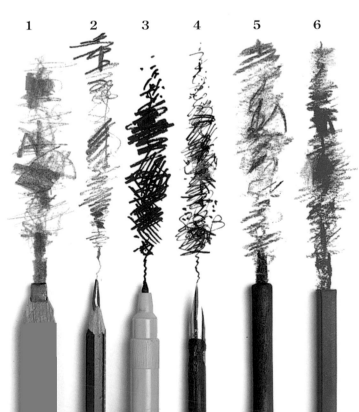

◀ Some useful drawing implements
1 *Carpenter's pencil*
2 *4B pencil*
3 *Fibre nib marker (black)*
4 *Dip pen*
5 *Charcoal stick*
6 *Conté crayon*

such as 5B or 6B pencils, conté crayon and charcoal sticks will make more distinctive marks which can be employed with watercolour to produce more of a line and wash effect. For cleaning up a drawing or making an erasure, use a putty rubber rather than the standard pencil rubber as the latter will damage the paper.

SPONGES

You will find it handy to have a sponge or a wad of cotton wool to mop up paint and correct errors, while dampened cotton buds are ideal for cleaning up details. Also, dabbing a wet sponge into drying paint gives a patterned effect which can suggest, for example, certain types of foliage or stony ground.

▶ Still Life with Oil Lamp and Green Bottle
41 × 23 cm (16 × 9 in)
Really fine detail can be added to a watercolour by using gouache paint. In this painting most of the highlights on the bottle and lamp were added in this way. The highlights on the brass of the lamp were given a yellow-green cast by adding a minute amount of watercolour pigment to the gouache. Overuse of gouache is to be avoided as the result can look false.

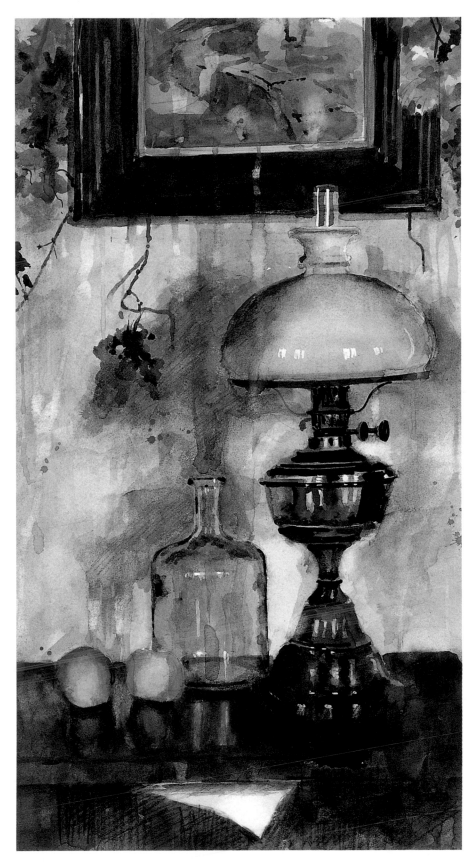

13

WATERCOLOUR TECHNIQUES

The techniques of painting in watercolour don't necessarily have to be learnt before painting can begin. Rather, they are usually picked up during the course of painting by a process of trial and error. It is primarily by committing mistakes, making joyful discoveries, enduring disappointments and achieving successes that you will become a proficient watercolourist.

The scope of these few pages on watercolour techniques is deliberately limited; the information is sufficient to get you started if you are a beginner but also, it is to be hoped, of interest even if you do already have some experience. While its main thrust is towards the rendering of light in all its many forms, it is equally applicable to painting watercolours of a more general nature.

APPLYING PAINT

The application of paint to paper is normally achieved with a brush, although there are other methods, too: fingers, sponges, sticks, even nailheads and rulers have all been used for the purpose. The brush, however, still remains the principal tool of the watercolourist and the range of marks it can make is very wide indeed.

It is important that you match the brush to the task you wish it to perform. Use large brushes –

◄ Holding the brush at a near-vertical angle will produce small, carefully controlled marks. Use this angle for painting detail.

◄ Holding the brush at an oblique angle creates broader areas of colour, useful for painting quickly and loosely. More interesting brushmarks are possible.

mops and rounds, size 12 and above – for laying flat washes over a large area such as a sky. Smaller brushes will not give good results here. For painting details, small brushes (sizes 0, 1, 2) are fine – but don't overuse them. Watercolours painted with too small a brush often look cramped and bitty.

Experiment with the angle at which you hold your brush. Painting with it almost vertical will produce small marks, while employing it flat, almost parallel to the paper, will give you larger, softer areas of colour. Painting

with your brush slanted at a variety of angles will help you to produce watercolours of distinction and originality.

USING WATER

The tone of a colour (by which is meant its lightness or darkness) can be controlled by the amount of water that is added to it. Increasing the quantity of water will also make the paint more transparent. Diluted pigments can thus become like coloured glass; for example, a yellow

painted over a previously dried blue will normally result in a shade of green.

The commonest way of using water is to add it to the paint in the palette until the required dilution has been reached. However, it is worth exploring the interesting effects you can obtain by adding water to wet paint already on the paper surface. In one of these effects, known as granulation, the action of water causes the pigment in a colour to separate out and produce a grainy or mottled quality. With experience this granulation can be controlled to a certain extent, but it is best for the painter to be prepared for some unintended results.

If the watercolour is of a thick consistency dropping water into it will cause the paint to form into irregular patterned shapes that are known as backruns, or cauliflowers. While purists consider these to be painting errors, the view of many other watercolour artists is that they are a part of the surface effects common to watercolour and as such they contribute to its distinctive appearance.

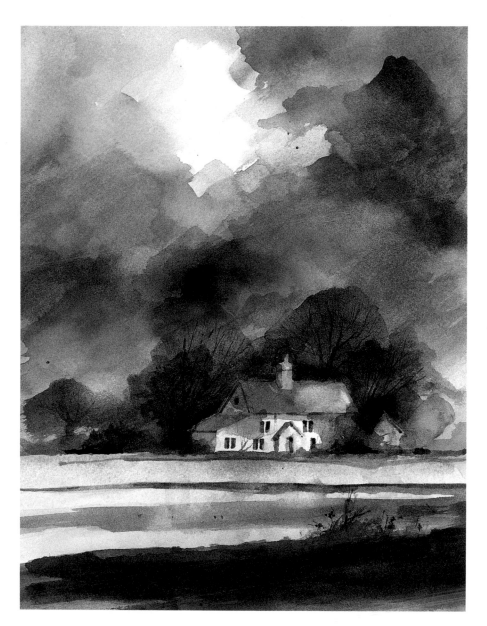

▲ Granulations
Yellow Ochre, Burnt Umber, Coeruleum and particularly French Ultramarine are prone to granulate. Though unpredictable, the effects are often beautiful.

▲ Backruns
Dropping water or wet pigment into freshly applied paint creates backruns, or cauliflowers.

▲ Unsettled Sky
35.5 × 28 cm (14 × 11 in)
Most of this subject was painted with a 16 mm mop brush and a No. 12 Round brush. The sky was built up in successive washes, allowing the painting to dry in between. I applied the watercolour freely and employed damp cotton wool to mop up any mistakes. Cotton wool can also be used to manipulate the paint as it lies on the paper.

15

MIXING COLOUR

To an inexperienced painter, the subject of colour is a confusing one. The range of watercolour pigments available is enormous (some paint manufacturers show 80 colours in their paint charts), while the terms used to describe the theory of colour can seem totally irrelevant to the practical problems of mixing paint. Don't be seduced by all the tempting colours on offer – it is better to work with a limited palette of colours you know than an extensive range with which you are only partly familiar. A range of useful colours is suggested on page 9.

It might be said that the best way to learn about colour and colour mixing is just to get on and do it; there is no substitute for practical experience. While this may be true, there are a number of useful points to be borne in mind before you get down to work.

KEEPING COLOURS CLEAN

The colours available in watercolour can be deliciously pure and delicate, yet these qualities will be ruined if they are mixed in dirty palettes or with dirty water or brushes. Colours mixed with liberal amounts of water can produce pale, transparent tints but they will quickly become degraded by even the smallest amount of unintended colour. It is therefore very important to keep your equipment as clean as possible.

In addition, overmixing your colours can easily produce a muddy result. Overmixing often results from the artist trying to mix a hue from too many

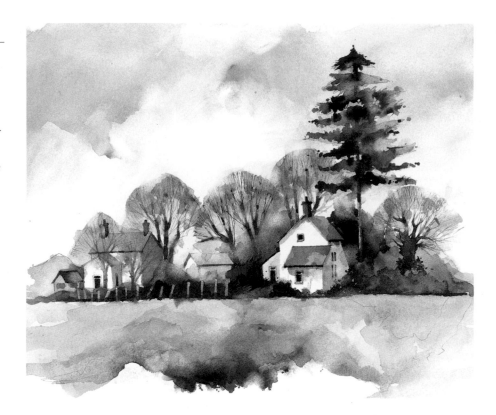

Cadmium Red

French Ultramarine

Lemon Yellow

▲ Painting with a Restricted Palette
41 × 33 cm (16 × 13 in)
With just three pigments it is possible to create an extremely wide range of colours. Select three primary colours, a red, a blue and a yellow, and experiment with them. Working with a simple palette you will really get to know the colours you use, their potential and their limitations.

colours. It is better to keep your mixtures simple; as a general rule, aim to use no more than three colours in a mix.

COLOUR RESTRAINT

In contrast to paintings with muddy hues, many watercolour paintings are unsuccessful because the colours are too bright. This is usually caused by the artist applying colours directly from the tube or pan. Of course there are occasions when really bright colours may be

▶ In a Bedroom
at The Dell
(sketch)
The shirt over
the back of the
chair is brushed
in with Crimson
Alizarin (a).

a

▶ *Here Crimson*
Alizarin (a) *has*
had French
Ultramarine (b)
laid over it to
change its hue.
Make sure that
the first colour
has dried before
applying the
second.

a

b

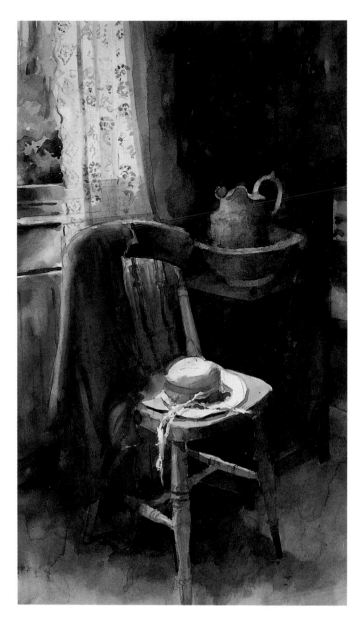

required in a painting, especially if the subject is in strong light, but it is good general practice to reduce the brightness of colours by mixing them. When you do use a colour unmixed, remember that adding water to it will reduce its intensity as well as lightening its tone.

MANIPULATING COLOURS

A surprisingly wide range of colours can be mixed from a limited range of pigments. By adding clean water to the mix colours may be tinted out to the lightest of tones, while shades of colour can be created by mixing in a neutral colour or black.

If, having laid down your colour, you find it unsatisfactory it is often possible to change it. Laying a transparent watercolour over a previously dried colour will slightly change its hue. A green, for example, can be made cooler, darker and bluer by painting over it with a dilute blue wash. Painting over the same colour with a yellow can in many cases produce a more yellow and sometimes warmer green.

▲ In a Bedroom at The Dell
40 × 27 cm (15¾ × 10½ in)
I have painted the wall and jug in
bluish colours to contrast with the red
of the shirt on the chair. All the
colours have been heavily neutralized
so that the bright tone and colours of
the hat and seat of the chair stand
out strongly. In the subject the floor
was quite light but I painted it in
degraded colours to focus attention
towards the centre of the painting.

▲ Bottle Collection II *(detail)*
This detail shows how the water has created an interesting pattern by causing the pigment to separate out and form a distinctive backrun. This feature of the watercolour process can introduce elements of abstraction into a figurative painting, providing interest in an otherwise mundane subject.

WET-IN-WET

Painting wet-in-wet means that watercolour paint is laid on to previously applied paint while it is still wet. This can produce beautiful, soft results. Because the paint runs into wet areas, hard-edged shapes and lines cannot be defined. Wet-in-wet is therefore used for such subjects as the sea and misty landscapes.

The usual way of working is to dampen the paper slightly before you begin painting. Lay colour on the paper with a brush, controlling runs with a tissue or sponge. You can drop more paint into the wet watercolour to deepen an area of tone, but it is important not to allow the paper to become too wet because the colours become uncontrollable.

Paintings making use of the wet-in-wet technique tend to be somewhat weak tonally and can be rather insipid. The best method of working is to use a wet-in-wet technique first, laying down watercolour in successive washes until a complete wet-in-wet look has been accomplished, then allow the painting to dry before adding detailing.

WET-ON-DRY

Watercolours of crystalline beauty can be created by this method of working. Watercolour is applied to a dry paper surface, and further colours are laid down only when the previous one has dried. Using watercolour in overlapped pale washes creates the effect of pale-coloured glass, but when stronger colour is applied with small separate brushstrokes it takes on a deeper, glowing appearance.

You can use wet-on-dry methods to achieve a depth of colour which surpasses wet-in-wet methods, building up layers of the same colours to an opaque solidity. However, do not build up the paint excessively as too many applications can create an unpleasant shine on the paint surface. In addition, if you use a variety of colours (blue over yellow over red, for example) the result will become muddy. The best results seem to occur when no more than two colours are overlapped.

Waiting for the paint to dry between applications can be tedious, but you can shorten the waiting time by using a hairdryer. Set it at half speed if possible and do not hold it in close proximity to the painting or it will blow the paint all over the paper surface.

The hard-edged nature of wet-on-dry methods can make it very difficult to create the atmospheric effects of distant, hazy views or soft interior lighting. Many watercolourists use wet-in-wet in conjunction with wet-on-dry methods. Part of a painting might call for a much more fluid technique, for example a stormy sky in a landscape, while the remainder is painted wet-on-dry, the two methods complementing each other. The result can be a watercolour comprising all that is best in the medium.

▼ Still Life with Oil Lamp
33 × 43 cm (13 × 17 in)
Although both the background and foreground were painted with very freely applied wet colour the main subject matter was much more carefully controlled. The tones were built up by painting fresh watercolour over previous applications when dry. Detailing too was applied wet-on-dry. Working this way allows a much greater degree of control in the process. Note where I have used white gouache as a final detail on the oil lamp.

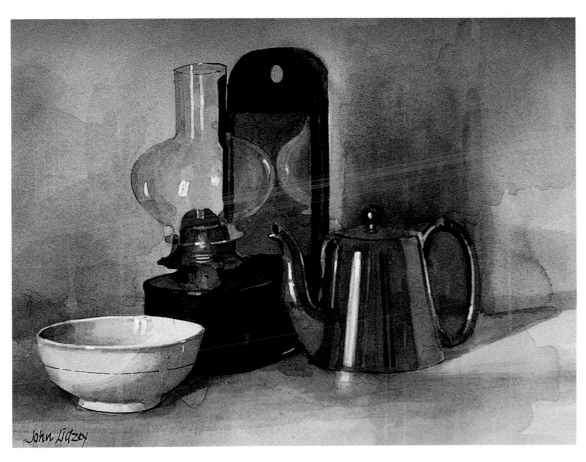

John Lidzey

▲ Flowers from the Garden
38 × 23 cm (15 × 9 in)
The simplest way of creating white spaces is just to paint round them, leaving the white paper to remain as part of the finished painting. Working this way will give sharp definition to the painting, with a brighter result. This method of creating spaces is known as 'reserving'. A disadvantage is that it is not practicable to paint round very fine details.

▶ Early Evening
9 × 15 cm (3½ × 6 in)
Dry paint can be lifted out with clean water. Some colours will lift out more successfully than others, but in most cases a small residue of colour will be left if the paper surface is not to be damaged. To lift out the moon in this painting I cut a circular hole in a piece of writing paper, positioned it on the painting and gently rubbed out the paint with clean water. The overlapping parts of the tree were added when the paper was dry.

CREATING WHITE SPACES

One of the many ways of bringing a sense of light into a watercolour is to leave certain areas unpainted, and you can achieve extra radiance of colour by offsetting white space against bright hues. Another method is to make highlights a special feature of a painting. Low-angled lighting will often produce highlights on the edges of forms and shapes in both exterior and interior subjects.

There are a number of methods of creating such white spaces in a watercolour, each one possessing its own special characteristic.

RESERVING

The simplest method of creating a white space or even a highlight is first to paint round the area to be left white, taking great care to be accurate as you do so. This method is probably most useful when larger areas are to be unpainted. Small white shapes such as highlights are difficult to reserve, especially if the watercolour is being painted with any degree of looseness, when it's very easy to paint over them in error.

LIFTING OUT AND SCRAPING OUT

Some colours can be lifted out after they have dried, although it will probably not be possible to get back to white paper. Using a brush laden with clean water, first damp the paint to be lifted and then gently dab or wipe it off with damp cotton wool or a dry tissue. You may need to repeat the procedure more than once. This may mean that the edges of the lightened area may be slightly soft or woolly, unless you have used a mask (see below). Lifting out is a useful technique where a soft, hazy light is wanted – in a sunset scene, for example.

Scraping out paint with a scalpel will produce small white highlights which are ideal for suggesting highlights on water, for example. Make sure your scalpel is sharp and that you employ a light touch. This technique is not recommended with papers of less weight than 300 gsm (140 lb).

▲ 1

▲ 2 ▼ 3

▲ Masking fluid can be used in a wash to create precise unpainted details that would be difficult to achieve by reserving.

1 *First apply the masking fluid over the areas to be left unpainted.*
2 *Next lay on the watercolour pigment.*
3 *When the watercolour has dried, gently rub off the masking fluid with a fingertip, revealing the unpainted parts. You can see the application of this method in the painting above right.*

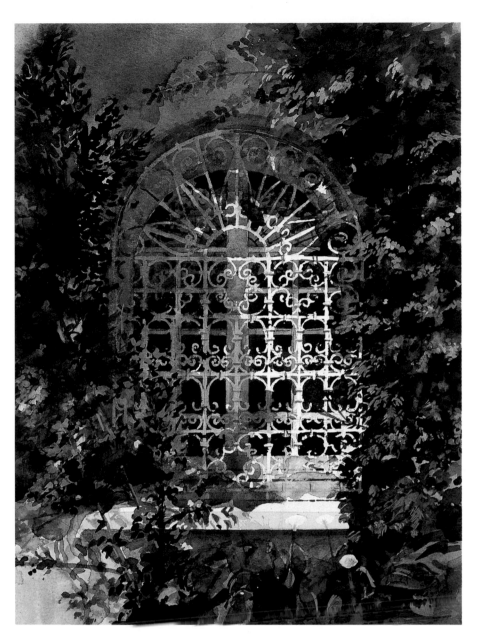

MASKING FLUID

Masking fluid is an adhesive rubber solution which makes it possible to leave specific shapes untouched. It can be applied with a brush or pen before or after a layer of paint has been applied. When the painting is finished, rub it off gently with a fingertip to reveal either white paper or the layer of paint.

Don't use your best brushes for applying masking fluid and always wash the brushes out in soapy water before and after use.

WHITE GOUACHE

Gouache, or body colour, is sold in many colours. However, white gouache is of particular use to the watercolourist to paint in highlights or other little local details when the painting is finished, as well as to tidy up reserved highlights and other small unpainted areas. This paint should not be overused or its presence becomes obvious and distracting, but applied with restraint it can blend in with watercolour perfectly.

21

COLOUR AND LIGHT

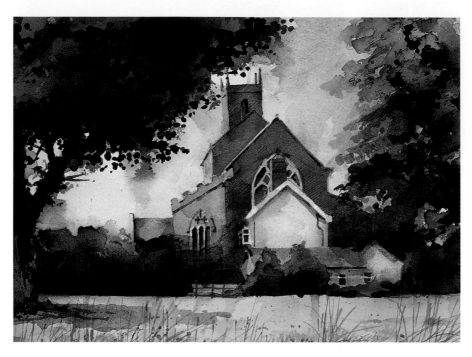

The colours we see around us are affected by the quality and angle of the light upon them. Sunlight striking a field of grass under certain conditions can make the grass seem yellow, while a redbrick wall may appear violet in evening sunshine. Such lighting conditions can produce a range of dazzling effects which, if carefully interpreted, can give watercolours a visionary intensity. Alternatively, the colour of an object can be affected not by direct light but by reflected light; even a pale-coloured blouse can lightly reflect its colour onto the wearer's face, while a white tablecloth may repeat the colour of an adjacent curtain purely by the action of light bouncing from one surface to another.

PAINTING COLOUR AND LIGHT ON LOCATION

In the landscape, unexpected colour conditions are created by fields of brightly coloured flowers. The brilliance of rape in full flower can be stunning and even on dull days it can cause surrounding vegetation to look dull and the sky to lose its intensity. To capture contrasting effects like these, tone down greens and reduce the value of your skies by the additions of small amounts of Payne's Grey or complementary or contrasting colours to your mixes. In direct sun colour can be reflected into surrounding areas, so you should again look to modify your colours. The foliage of adjacent vegetation might be painted in

▲ Church at Redgrave, Suffolk
28 × 38 cm (11 × 15 in)
To suggest the effect of a summer's day I used clear, bright colours in the sunlight, mixed from Aureolin, Prussian Blue, Indigo, Yellow Ochre and Rowney Vermilion. In the shadow areas I used cool colours mixed from Lemon Yellow, Indigo, Payne's Grey, Prussian Blue and Crimson Alizarin. The sky was loosely brushed in using French Ultramarine. The church was in deep shadow but I lightened it and introduced more colour than I could see in the subject to contribute to the warmth of the scene.

yellow-greens, but be careful not to exaggerate your colours.

If you paint against the light, many parts of your subject will be darkened and lack detail. Keep these areas slightly dulled ('degraded'). Use colours that are too dull rather than too bright as you will be able to contrast them with brighter hues in areas of direct sunlight.

If the light is behind you, areas of shadow will have more colour in them. Shadows should never normally be painted in black or cold greys, even in urban scenes. In city streets on sunny days watch out for light which reflects off sunlit walls into areas of shadow and infuses them with colour from the surrounding buildings.

REFLECTED LIGHT ON WATER

A single stretch of water can assume many different colours according to the nature of the light, the weather conditions and the angle of view. Clear water can reflect grey cloudy skies as well as blue ones, so consider the possibility of using a colour similar to the one you used for the sky, ensuring that the water has a similar degree of lightness. If the water itself is muddy or greenish you may need to adjust your colours slightly and the reflections of objects may need to be painted in slightly duller (less intense) and darker tones. Observe the colours very carefully and paint what you see.

▼ *Early Morning Light*
29 × 41 cm (11½ × 16 in)
To convey the quality of light in this watercolour I created extremes of light and dark colours. The foreground was painted mainly in mixes from Indigo, Payne's Grey, French Ultramarine, Cadmium Yellow Deep and Cadmium Red. The lighter colours were kept as pure as possible and were mixed from Cadmium Yellow Deep, Rowney Vermilion, Carmine, Aureolin and Monestial Blue.

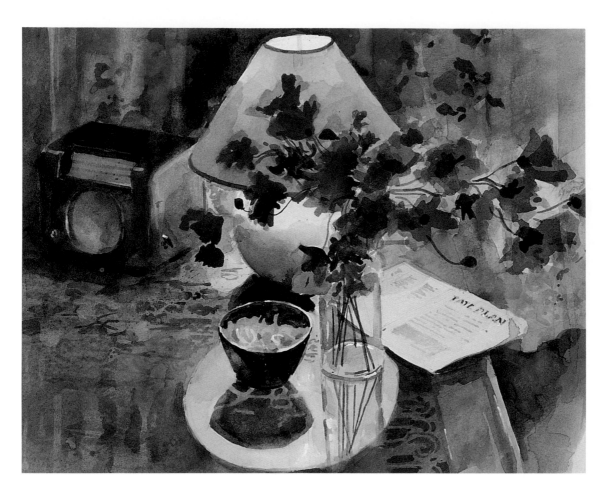

COLOUR AND ARTIFICIAL LIGHT

Artists often paint under artificial light, working from photographs or from sketches and drawings. It is important to remember that artificial light can have a pronounced effect on colour mixes; in daylight, the colours in a painting can look markedly different from how they appeared when viewed under artificial lighting conditions. Tungsten bulbs give a yellowy-orange light and many fluorescent tubes cast a light warmer than daylight. It is possible to purchase daylight bulbs which will fit into an anglepoise or similar lamp, and these will help to make your colour mixes more consistent.

You may of course wish to paint an interior scene lit by artificial light. Such subjects can make wonderful paintings. In a painting of a table lamp casting its light on adjacent objects, such as a cup and saucer and a bowl of fruit, the yellow light of the tungsten bulb would be a feature of the painting, but remember that a coloured lampshade could have a further effect on the colour of the light. A painting such as this might make pronounced use of Yellow Ochre, Cadmium Yellow, Cadmium Red, Raw Sienna, Raw Umber and Burnt Umber. Avoid painting shadow areas in cold colours – the overall effect should be one of warmth. The best mixes to use here would be from Burnt Umber, French Ultramarine and Cadmium Red. Areas in strong light should be painted in pure colours; Yellow Ochre and Cadmium Yellow Deep in weak mixtures will work well.

▲ Still Life with Poppies and a Table Lamp
28 × 34 cm (11 × 13½ in)
The table was painted with a mix of Cadmium Red, French Ultramarine, Yellow Ochre and Payne's Grey. For the poppies I used a much purer and simpler mix of Carmine and Indigo. The lampshade is in Yellow Ochre, but I allowed some of the poppy colour to bleed into this colour while wet. There is an overall warm cast to the colours consistent with the nature of artificial light.

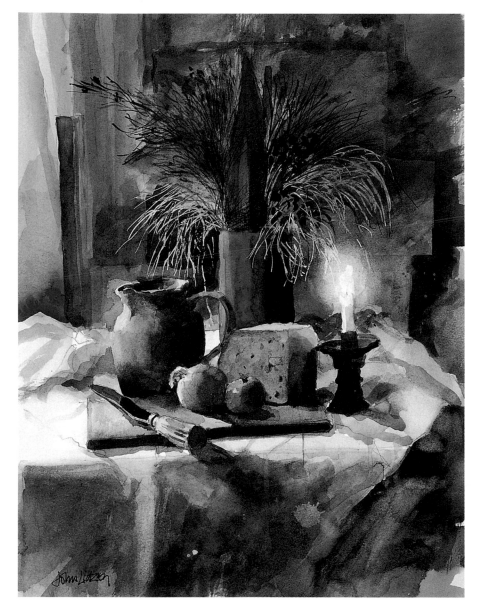

◄ In the Kitchen
35.5 × 24 cm (14 × 9½ in)
I have contrasted blues and greens in the background and foreground with the warmer food colours. The candle flame is suggested by a halo of light. It seems bright, but the shadows are cast by a light source out of the picture area. The colours I have used are Indigo, Aureolin, Burnt Umber, Cadmium Yellow, Yellow Ochre, French Ultramarine, Cadmium Red, Crimson Alizarin and Payne's Grey.

An interior lit by fluorescent tubes will have a flat, unpleasant illumination which provides little or no contrast of light and shade. Painting by this light is not to be recommended. Switch off half the room lights to create more contrast and use portable tungsten lighting in the form of table or standard lamps to provide areas of strong light and shade which will be more interesting to paint.

Some useful points to bear in mind are:

1 Sunlight will change colour slightly or sometimes dramatically according to the time of day, the season of the year and the weather conditions.

2 Bright colours will always seem brighter if set against areas of dull, neutralized colours.

3 A coloured surface will reflect some of its colour upwards into an object upon it.

4 White objects are rarely completely white.

5 Unless they have a very matt surface, black objects can take on the reflections of other colours.

Tips

● Watercolours will normally dry to a lighter tone than when wet, so allow for this when you apply your washes.

● Make several sketches of a subject using alternative combinations of colour. Be prepared to experiment rather than being limited by what you see.

LIGHT, SHADE AND TONE

The word 'tone' is used to describe the lightness or darkness of a colour. If you lay down a small patch of paint from each colour in your paintbox you will notice that some are light in tone and others are dark, for example Lemon Yellow and Vandyke Brown respectively.

EXPLORING THE RANGE OF TONES

The tone of any colour may be lightened by the amount of water added to it. It is possible to obtain a greater range of tones from a dark colour than from a light one – for example, a scale of Payne's Grey would be much longer than one created from Cadmium Yellow. The capacity of watercolour to provide a wide and subtle range of tones is one of the strengths of the medium.

It is a good idea to explore the light and dark qualities of your paints by creating tonal scales of each colour, showing the pigment tinted out progressively from its fullest strength to its weakest by the addition of clean water. Keep the results in the back page of your sketchbook, or pin them on the wall above your work table. You could also paint patches of colour which compare one hue with another in tonal terms – for example, mix a green which is the same tone as a red. When you have done this, using French Ultramarine and Yellow Ochre, lighten the blue with water until it is paler than the yellow; and finally create a blue and yellow the same tone as each other.

◀ Elsie at The Dell
Before you begin a painting it is often a good idea to make a tonal sketch of your subject, even if it is only roughly done. This one was drawn using a 2B conté crayon similar to the one in the illustration on page 12.

TONE IN THE SUBJECT

Many people new to painting find that they have difficulty in judging the range of tonal values in their subject. This is because they are distracted by other considerations such as colours, highlights and shadows. Another cause of confusion is that light can alter the natural tonality of objects. Dark objects in bright illumination can appear to be light, while conversely light objects in shadow can be seen as dark. It is tempting to paint objects in the tone we know them to be rather than as they appear in strong light – but don't paint what you think you see, paint what you *do* see!

household paint. Reflected in this glass, the colours of your subject will be reduced to tonal variations. The Claude Glass is an 18th-century invention, used by many painters of the time to solve their tonal problems. It may be that it contributed to the pleasing tonal effects achieved by many 18th-century painters.

Another method of separating the tonal values in a subject is to photograph it in black and white, or to take a colour photograph and then copy the result on a black and white photocopier. This will not only produce a tonal copy of your subject but will also simplify the tones so that you are not tempted to overfussiness in your painting.

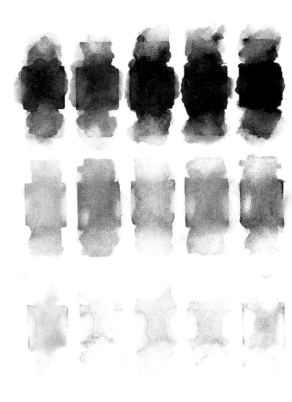

LOOKING FOR TONES

To paint tonal values accurately it is important to put colour and preconceptions aside and look for the lights and darks in the subject. Half-closing your eyes when viewing it can help but you will also need to look at your subject objectively, as patches of different tones, interpreting them with appropriate tones from your paintbox.

It is a very good practice to make tonal single-colour studies of your subject prior to painting in full colour as this will help you to distinguish between light and dark. If, however, you have looked at your subject with great care and attempted single-colour studies but still find difficulties in separating one tone from another, there are two possible ways of solving your problem.

The first is to make yourself a Claude Glass. This is simply a piece of clear glass cut to 25.5 × 20 cm (10 × 8 in) and painted on one side with black

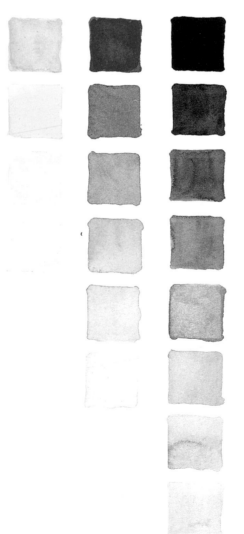

▲ Colour and tone comparison
This chart shows that tonal strength (darkness and lightness) of colours can be controlled by the addition of water. For example, a red which is normally darker than a yellow can be lightened so that the two colours are of the same tonal strength.

◀ Tonal scales
A light colour such as Lemon Yellow has a much shorter tonal range than a darker one like Payne's Grey.

FINDING TONAL SUBJECTS

It can sometimes happen that a subject which is interesting in itself will not make a good painting because its lighting is poor and so there is insufficient tonal contrast available. Such a situation is most likely to occur on cloudy days, when towns and cities can look particularly drab. One solution is to wait for better lighting conditions. Alternatively, it is often possible to find a good tonal subject by investigating promising angles of view. A low painting angle against the sky or an open aspect can frequently reveal contrasts of light and shade which will make for an effective painting.

In good weather the strongest outdoor tonal subjects are usually found at midday. The shadows are hard and dark but they are also at their smallest, so that a scene at this time of day can be flooded with sunlight and thus present a somewhat bland appearance. Many landscapes painted in such conditions are disappointing because of the lack of shade. If this is the case, try to do the painting later in the day.

Tip

● Gouache paint can be useful for creating dark areas of tone, but use it with restraint or the watercolour effect will be lost.

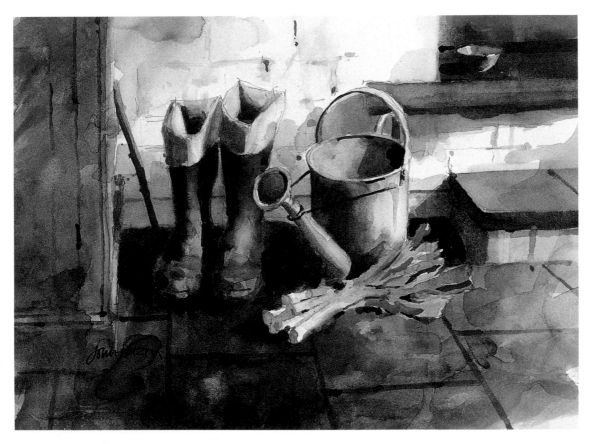

◀ In from the Garden
27 × 42 cm (10½ × 16½ in) A subject like this calls for careful observation of its tonal values. The diagram below shows parts of the painting with which I was particularly concerned.

◀ Tonal notes
1 Edge of the watering can becomes lost in its own shadow.
2 Black objects (wellingtons) have capacity to reflect light.
3 Shape of bowl suggested by simple changes in tone.
4 Leeks positioned so that light and dark tones contrast with each other.

5 Although the wall is white its tone is lowered with a light French Ultramarine wash.
6 Low tone of cupboard on left-hand edge gives stability to the composition.

It is often said that watercolour is not a tonal medium, by which it is meant that light, transparent colours cannot create really low tones. However, there are in fact methods for producing these (see page 31), and in many cases the richer and deeper the darks the more radiant the effect of light. A patch of sunlight in shade under a tree or light reflected from a lake can be excitingly captured if tonal values are carefully managed.

You can experiment with the effects of light and shade by painting a sunlit window and shadowed interior wall. First draw the window and some of the wall. Note the dark and light areas on the frame and wall and record them in your painting. Explore all the tonal possibilities. Some parts of the window frame in shadow, although light in colour, may look tonally dark. Other parts in sunlight may look white, or nearly white.

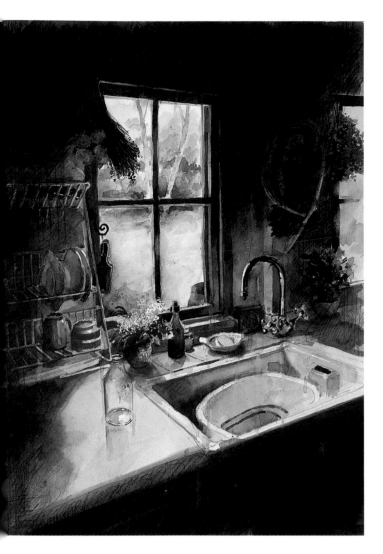

▲ Kitchen Sink
61 × 41 cm (24 × 16 in)
This old-fashioned kitchen is a wonderful place to paint. Its windows are rather small, so areas of bright light and shade occur side by side. To capture this chiaroscuro *effect in watercolour it was necessary to deepen the tones of the dark areas while painting the lighter areas with the palest of washes. You may be able to see that I have scribbled black conté over some of the shadow areas. Mixing the two media like this can give a distinctive quality to the painting.*

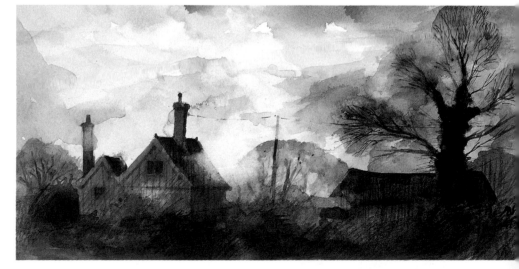

▲ Early Evening at Ellingham
17 × 29 cm (6¾ × 11½ in)
Painting a landscape towards the end of the day in autumn can be a joyful experience. There may be a
beautiful glowing sky with trees and houses in partial or full silhouette against it while low sunlight shines through dying foliage, giving it a luminous quality.

LIGHT AND DARK TONES

Direct or reflected light may often need to be painted in pure or nearly pure colours and sometimes really bright light might require them to be very heavily diluted, tinted out to the palest of hues. Conversely, areas in shade may often need to be darkened or neutralized.

Many people find they have difficulty in mixing very light and very dark colours, but with experience this aspect of watercolour can become quite straightforward. Strong contrasts of light and dark colours as well as bright and degraded ones will help you achieve paintings which seem to radiate light.

LIGHT COLOURS

Beautiful, glowing colours can be mixed from watercolour, especially those pigments which have the greatest degree of transparency. These colours, when sufficiently diluted, allow the whiteness of the paper to show through. Their luminosity makes them ideal for creating the effects of atmosphere, space and light. Some colours can be tinted to such an extent that when painted down they do little more than lightly stain the paper.

If you wish to mix a tint of a pure colour it is important that your water, palette and brushes are absolutely clean. Of course, not all light colours need be pure – extremely subtle colours can be created using just two colours. Green-greys can be mixed from Yellow Ochre and French Ultramarine, while warmer greys can be made from Burnt Umber and Cobalt Blue. Rather than using a proprietary brown colour, mix pale browns with Cadmium Orange and Permanent Blue or with Yellow Ochre and Permanent Mauve. Experiment with these colours in a variety of dilutions and see what marvellous results can be achieved.

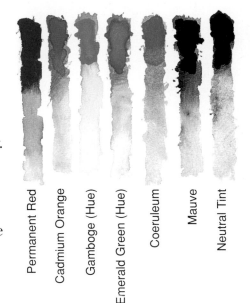

Permanent Red · Cadmium Orange · Gamboge (Hue) · Emerald Green (Hue) · Coeruleum · Mauve · Neutral Tint

▲ From dark to light
Colours at full strength can be lightened to the palest of tints by progressively adding water. Using Chinese White or white gouache will also lighten colours, but the result will be opaque.

◀ Transparent colours
a French Ultramarine, b Prussian Blue, c Viridian, d Sap Green, e Raw Sienna, f Carmine, g Permanent Red, h Payne's Grey.

◀ Opaque colours
i Indian Red, j Cadmium Red, k Yellow Ochre, l Lemon Yellow, m Cobalt Green, n Coeruleum, o Burnt Umber.

LOW-TONED COLOURS

If you wish to paint a pure colour at its darkest possible tone, mix it with only a very small amount of water. Attempting to darken a colour by adding Black or Payne's Grey will in many cases change its hue – yellow, for example, will usually become somewhat greenish.

You may find that just one application of paint is insufficient to create a suitable depth of tone and that you need to paint over the same area two or even three times. Painting over the top of a colour which is still wet will not achieve a satisfactory effect, so make sure that each application of paint has dried before laying the next on top.

NEUTRALIZED COLOURS

Useful low-toned neutral colours can be obtained by mixing two or three pigments of distinctly separate hue together. By using only a small amount of water it is possible to mix a near black or dark grey containing just a hint of colour. If your painting requires an area of deep shade a neutral colour you have mixed yourself can often be much more successful than a black or Payne's Grey – for example, beautiful low-toned greys can be made from mixes of Indigo and Burnt Umber or from Cadmium Yellow mixed with French Ultramarine and Carmine.

It is a good idea to make a small chart of a range of light and dark greys mixed from colours in your painting kit. Begin by mixing blues with earth colours. From just a few pigments you can create a range of satisfying colours.

Permanent Red

Monestial Blue

◄ **Building up tones**
A colour can be darkened by building it up with successive applications, wet-on-dry.

Tips

● Areas of shadow and small areas of low tone can be darkened by scribbling conté crayon on the colour. Rub it in lightly with a fingertip and use a fixative afterwards.
● Watercolours can be made opaque by mixing them with a thickening gel obtainable from most art shops.

▲ Warm greys
*I have mixed Naples Yellow (**a**) and French Ultramarine (**b**) to create some warm greys of varying strengths. Try also Coeruleum and Light Red.*

▲ Cool greys
*The mixture of a blue with an earth colour, in this case Cobalt Blue (**a**) and Burnt Umber (**b**), will usually produce a cooler grey. Try also Gamboge (Hue) and Ivory Black.*

SHADOWS

The presence of light and shade defines shape and form, enabling us to make visual sense of the world. Shadows can also convey more subtle information; for example in a landscape they can suggest the time of day, the season, the weather conditions and even in some cases the air temperature. Shadows, then, are worthy of close investigation.

CAST SHADOWS

An object illuminated from the side will be light on one side and dark on the other, and will cast its own shadow. Depending on the quality and strength of the light, cast shadows can vary from quite light to very dark. In some cases the shadow on the side of the object can merge into its cast shadow.

This can occur as much in a landscape or city as in a sunlit interior. For example, evening sunlight might illuminate one side of a house while its shadow on the other side might dissolve into the darkness of surrounding trees or shrubbery. When you are painting such a scene it is very tempting to separate the shadowed side of the house from its cast shadow, depicting them as two separate entities. However, you can obtain a much more illuminated effect by treating both the shadow and cast shadow as one shape. It is a useful practice to study the subject through half-closed eyes.

▼ Still Life in Light
18 × 23 cm (7 × 9 in)
The subject matter for these three still lifes is identical, but I have altered the lighting for each one. The patterns of light and shade give each still life its own distinctive quality. In this case I feel that the one lit from above (centre) is the most interesting, possibly because the background is illuminated, throwing the jug and leaves into sharp relief.

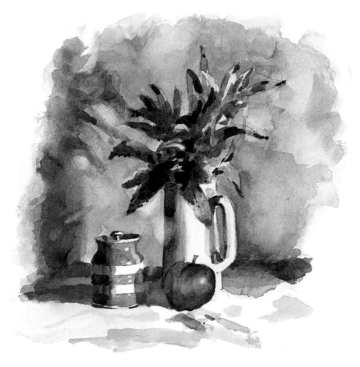

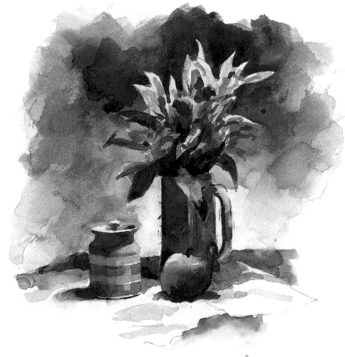

This will enable you to see your shadow shapes as complete wholes and help you to judge how light or dark they are.

COLOUR IN SHADOWS

In the 19th century, colour theories developed by the Impressionists advanced the idea that the shadow of an object of a particular colour will contain a trace of its opposite colour. Thus the cast shadow of a yellow vase might contain just a hint of violet or the shadow of a red ball might be very slightly green.

The colour of a shadow can also be determined by the colour of the light source or by the colour of the surface on which it is cast. For example, the shadow of a tree on grass can be painted in a degraded green, but at sunset the light might cause the shadow to deepen so that it is nearer to a dark brown.

Many shadows at first look just grey, but it is worth

persevering to see if you can discover the colours in a shadow. When you come to paint them, avoid using blacks or greys as they can have a deadening effect on the finished watercolour. Some watercolourists habitually use blue for their cast shadows, and while this colour can be inaccurate and overused it is better than cold, neutral colours.

If you have problems with shadow colours compare shadowed and light areas in your subject by viewing them through a 1 cm (½ in) square hole in a small piece of black card. Isolating shadows in this way will give you a clear indication of their individual colours.

▲ Sculpture in Shadow *33 × 32 cm (13 × 12½ in) Look for interesting shadow possibilities – the one on the wall cast by this figure makes a dramatic subject. I used wet-in-wet techniques in this painting to give a feeling of life to this very static piece of sculpture.*

33

◄ Cottages at St Cross
This painting is based on an old pen and ink sketch of mine. I like the strong feeling of sunlight in the original and wanted to capture it in my watercolour. The painting is not quite complete, but I have included it to show that I define shadows at an early stage in the painting rather than adding them as an afterthought.

SHADOWS IN LANDSCAPES

Because light and shade are so important in landscapes it is often useful to make preliminary inspections of your subject at various times of the day to determine the best position of shadows before you embark on your painting.

Some artists will always look for opportunities to paint into the sun, when most of their subject matter may be in near silhouette. Working this way is not easy on the eyes, but it can produce some interesting results. If, however, you are looking for dramatic long-shadow effects you will need the late evening or early morning sun shining straight on to or obliquely across the subject. Shadows emanating from a low light source give a well-defined shape to trees and foliage, making them easier to draw and paint.

On hot days, painting from shadow out into the light can not only be more comfortable but pictorially more rewarding.

Foreground trees and grass in shadow can have a frame-like effect in your painting, inviting the viewer to step out of the shadow and into the light.

SHADOWS IN CITIES

The shadows cast by buildings in city streets move all too quickly, and a scene can look totally different within an hour or less. This causes a problem for the painter. One way of overcoming it is to paint for short periods at the same time on successive days rather than attempting to complete a painting in one single session. If more than one visit to the location is impossible, begin your painting on site and make sketches of shadow positions or take photographs and complete your painting at home.

When you are painting urban shadows, consider their strength and definition. In bright summer sunlight the shadows cast by buildings can be dark and hard-edged, and if you paint them as

▲ View of Diss
This is a rapid sketch aimed at catching the pattern of lights and darks on the buildings. Working quickly is enjoyable and the results are sometimes interesting.

you see them the result can look overpowering or even unpleasant. In many cases it is a good idea to soften shadow edges and reduce their density unless, of course, your painting is making a special feature of shadow shapes.

The appearance of shadows can suggest the time of year. For example, in the winter the shadows, if they exist at all, will be less dense and less defined and certainly longer. As an exercise you could devote a whole sketchbook to the study of city shadows through the seasons, showing their length and general character.

SHADOWS IN INTERIORS

Look out for the possibilities of painting shadows in a room. The sun streaming through a window, especially in the early morning, can cast fascinating shadows on a wall. If the shape of the shadow is complicated and changes too quickly, a photograph of it will serve as a useful reference for completing the painting.

Extremes of light and shade can bring an interior to life, creating both warmth and interest. All too often, though, rooms are in total shadow, making them an unattractive proposition for painting. In these circumstances one solution is to create light and shade with a table or standard lamp; the light from just one lamp can create an attractive and very paintable subject. It may be necessary to experiment, trying the lamp in various positions until you have achieved an interesting shadow arrangement. It is better to use one lamp rather than two as

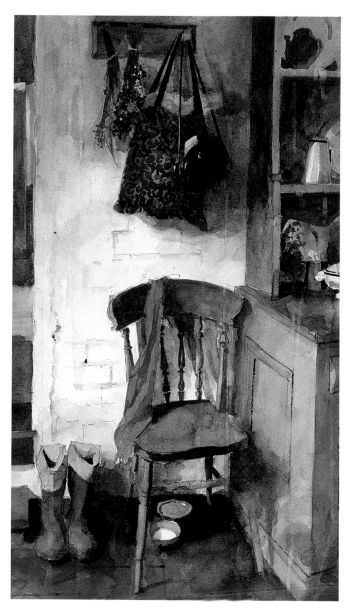

more than one light source will create complicated shadows which can look unnatural. Avoid using a ceiling light fitting only, because overhead lighting tends to give flat illumination with almost no shadow.

As an alternative to using artificial light, good subjects with plenty of shade can be found inside a window even on dull days. Make your subject the window itself with articles on the inside sill and soften what you can see outside the window, painting it in light tones with soft edges.

▲ Kitchen at The Dell
46 × 30.5 cm (18 × 12 in)
This painting complements the one shown on page 28. You may recognize the wellington boots! A small window to the left illuminates part of the wall, but the light falls away above the chair and towards the floor. The shadows from the bag and chair are particularly interesting to paint.

REFLECTIONS

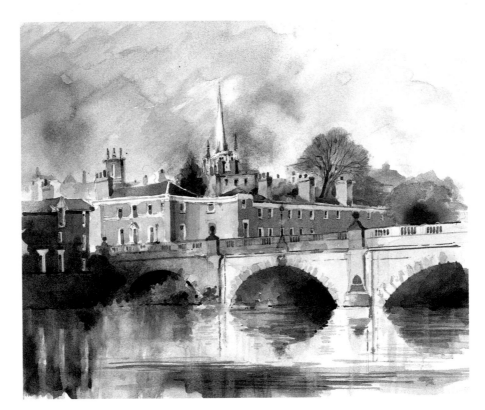

◀ The River
Bridge
*27 × 34 cm
(10½ × 13½ in)
Reflections of
arched bridges
nearly always
make a good
painting subject.
The pattern of
lights and darks
on the water
made this a
particularly
interesting
project.*

Reflected light always adds interest to a painting. Lakes, puddles, mirrors and even shop windows can reflect light, often in unusual ways. The light from the sky gleaming from a puddle in a winter landscape can create a magical effect and transform an ordinary painting into an outstanding one. Similarly, a mirror in an interior can reflect not only unexpected light but also objects that are outside the picture area.

LANDSCAPE REFLECTIONS

Lakes and rivers are the principal source of reflections in a landscape, mirroring the sky and, depending on the angle of view, the surrounding landscape or items in the water itself.

If the water is perfectly still the reflections will have a mirror-like quality which in some cases can look unreal; it is better to paint when there is a slight ripple in the water so that the reflected image is broken up. The ripples will decrease in size as they recede from you, which means that foreground reflections will be more distorted than distant ones.

In clear water, the reflected sky often appears as bright or sometimes even brighter than the sky itself, especially in puddles in muddy fields where there is a strong contrast between light and dark. Do not be tempted to paint it in a duller tone because it is just a reflection. However, in some cases you may need to paint the colours of reflections in rivers or lakes very slightly neutralized in order to avoid an effect of conflicting images.

CITY REFLECTIONS

Modern architecture makes extensive use of glass in the construction of buildings. In a big city it is sometimes possible to see the sky or even the sun

36

reflected from the glazed side of a tall commercial building. Such an exciting sight can be a very good watercolour subject, although it is probably better painted from a photograph rather than from life as the light can change much too quickly to allow anything but the swiftest of on-the-spot sketches.

On a less grand scale, a city in the rain can be a good subject for reflections too. Watercolour is a splendid medium for suggesting rain-soaked streets and glistening puddles. Painting wet-in-wet will help to provide a rainy-day effect, as will keeping the painting loose and avoiding excessive detail. Use greyed, neutralized colours for the architectural features and contrast these with the bright reflections in the puddles and on the road surface.

INTERIOR REFLECTIONS

There can be many reflective surfaces in an interior, such as polished steel, cutlery, kitchen equipment, framed pictures, window glass and mirrors. Their capacity to radiate light can make a delight of even the simplest painting of an interior subject or a still life.

When you paint reflective surfaces it is important to record carefully the tonal values in the subject. A reflection on a polished piece of silver, for example, will not look convincing if there is not a strong contrast between the lights and darks.

Light can even reflect from what might be considered to be a non-reflective surface; in sunlight, a dull table top might appear to glow with light. To create such an effect in a

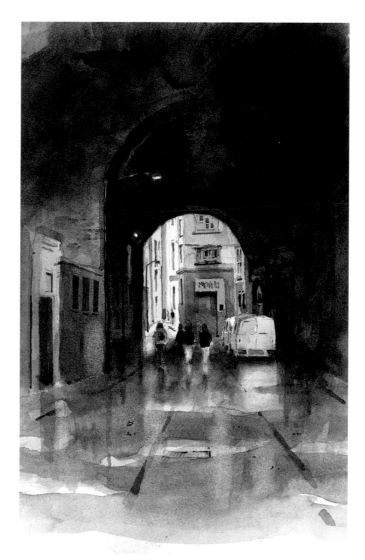

◀ Down by the Docks
32 × 23 cm
(12½ × 9 in)
Wet pavements can reflect light and the shapes of cars and people to provide additional interest to a scene. A loose painting technique will often contribute to the effect.

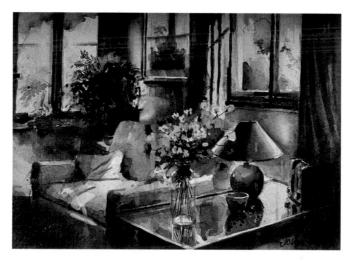

watercolour it may be necessary to leave the illuminated surface as unpainted paper while simplifying or even excluding details in shadow areas.

◀ Interior at The Dell
43 × 53 cm
(17 × 21 in)
This painting abounds in reflections. The picture on the dark wall reflects the window; the glass table top shows reflections of various objects and the glass jar reflects some light. I was pleased with the light airiness of this painting.

37

CHOOSING THE TIME OF DAY

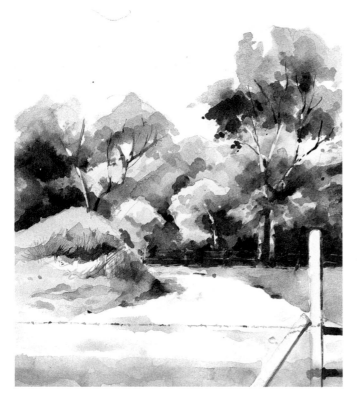

You will have noticed that just as the quality of light changes throughout the seasons it changes throughout the course of a day too. These changes in light will have a strong effect on the colours in both landscape and city subjects. This will of course affect your selection of colours and the colour mixes you use when you begin to paint.

LANDSCAPES

In a single day the colours in a landscape might be tinged with gold in the morning, bleached out by a fierce overhead sun at midday and then softened by a diffused, misty light in the evening. Because of the colour and quality of light at either end of the day many watercolourists choose one of these times for painting; not only are the colours seen to be more interesting but trees and foliage are considered to have better form and shape. Even fields of grass or wheat show textures which are absent at midday. Paintings late and early in the day might include warm and delicate colours: Cadmium Yellow Pale, Gamboge (Hue), Venetian Red, Raw Sienna, Coeruleum, Cobalt Blue. Midday painting could make use of brighter, stronger colours: Lemon Yellow, Cadmium Yellow

▲ Suffolk Bridleway, 10am
25.5 × 30.5 cm (10 × 12 in)
In the painting above left the sun falls obliquely, bathing the subject in light. There are no defined shadows. The dark shapes in the trees give them form but the foreground is featureless and bland.

Suffolk Bridleway, 5pm
25.5 × 32 cm (10 × 12½ in)
The light at this time of the day (above) is altogether more interesting than that in the morning. The sun is now behind the trees and is lower in the sky. The trees are more silhouetted and the foreground is in shadow. Trees and foliage are reduced to simpler shapes and are much easier to paint.

38

Deep, Permanent Red, Cadmium Red, French Ultramarine, Indigo.

Towards evening, sunlight can shine through foliage in a way that causes it to radiate with light. Such effects can breathe spirituality into a landscape.

The painters Poussin and Claude Lorrain produced some wonderful landscapes bathed in evening light. See them if you can, even in reproduction if you do not have access to some original paintings. They are inspirational.

CITIES

In the early morning, urban streets can have a silent and bare beauty all of their own. A low sun can reflect a golden light off buildings and morning mists can give sunlight a tangible quality.

Streets are easier to paint at this time of day as traffic is usually light and parked cars and vans are few. In many cases it is possible to stop at a suitable roadside point and paint from the comfort of your own car, using it as a kind of roadside studio. Working this way does usually mean that you will have to make a very early start, but the painting opportunities make it very worth while.

Buildings and street scenes at midday can also present splendid opportunities for the watercolourist. Shadows are harder and sharper and the light is stronger; commercial and industrial buildings can take on a sculptural air. Towards evening the sun is low again but there is a very different atmosphere to that of the early morning, with the rush hour in progress and people embarking on an evening's entertainment.

PAINTING CHANGING LIGHT

Remember that the sun moves all too quickly across the sky and in some circumstances shadows, light and colours can change dramatically in just a quarter of an hour. Because of this many painters work from photographs, but this is not always as easy as it may seem. Painting from a photograph will often result in rigid or stilted work, so if you are able to it is best to make a quick pencil sketch *and* take a photograph. Paint colour patches on your sketch for reference to use when you are able to execute the finished painting.

If you are feeling especially adventurous you may like to paint either a landscape or street scene at various times during the day – for example early in the morning, at noon and towards evening. If the weather remains consistent this will give you a good opportunity to see how the direction and quality of light can transform a scene.

It is probably best to choose an uncomplicated subject such as a small group of trees in the country or part of a building in town. Simplify what you see down to its bare essentials, concentrating on the shapes created by the light and shade. Half-closing your eyes when viewing your subject will make your task much easier.

▼ Gate to The Dell
24 × 38 cm (9½ × 15 in)
At certain times of the day during summer the light from the sun catches the ironwork of the gate, making it well defined against the background foliage. This occurs for only a very short time so I made a quick sketch of the pattern of light and used this as a reference when painting.

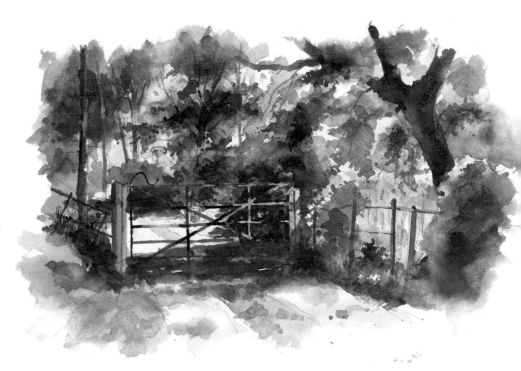

LIGHT IN STILL LIFE

You may often see a still-life subject in your home which already possesses all the qualities necessary for a perfect watercolour subject. Some fruit in a bowl with grapes spilling over onto a table or a few items of chinaware pushed haphazardly to one side can be the basis of a completely natural arrangement. Yet attempting to create a satisfying composition of the same objects by carefully arranging them seems to be a difficult thing to do – in spite of your best efforts the result will often look artificial or even stilted. So before you set up your own still life, look for existing possibilities. Examine even the most unlikely places: a shelf in the kitchen or a bench in a toolshed can often present a ready-made composition just asking to be painted.

If you do want to create your own still life it is best to keep it simple. Choose just a few items that will present contrasts in size, texture and shape; a china cup and saucer, a silver teapot and some flowers, for example, could make a very satisfactory grouping. Alternatively, select items which have a relationship with one another: a set of woodworking tools, perhaps, or cookery ingredients with a mixing bowl.

CHOOSING NATURAL LIGHT

The quality of the light is often the feature that makes a ready-made still life good to paint. For this reason windows or open doors can provide good sites – I have painted an interesting still-life of an apparently mundane scene of some wellington boots and a spade placed just inside a door to the garden. Other still-life ideas suggest themselves for

▼ Tea for One
(conté sketch)
A tonal sketch in conté or charcoal (below left) can be useful for sorting out problems of composition or just tonal values. In some cases a much more roughly finished sketch will do.

Tea for One
(watercolour sketch)
I often sketch all or part of a subject before beginning a painting. In some cases it is to test out an arrangement, in others to investigate colour or tone. Preliminary sketches can overcome the need to experiment while working on the final watercolour. The purpose of the sketch below was to test out the arrangement of items before going on to produce a highly finished painting.

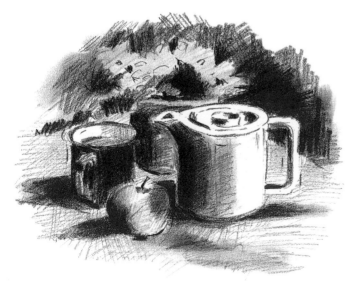

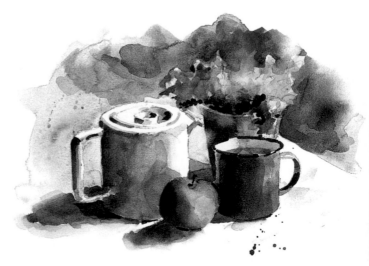

such a position: a chair with a shopping basket containing vegetables or possibly a damp umbrella with a raincoat draped over the same chair.

Interior windowsills often provide good lighting for a special set-up, but remember that a still life in direct sunlight can create a problem of rapidly changing light. It is probably better to paint on cloudy days when the light is more constant. You will find that even on these days the light will change from morning to afternoon, so it is better to confine your painting to just one of these periods.

CREATING YOUR OWN LIGHT

Natural light may not provide suitable illumination for a still life – indeed, it may be barely available at all on dark winter days. In this case you will need to supply your own light source. Use one which can be moved easily and adjusted in height, such as an anglepoise or even a photographic lamp.

Once you have arranged the components of your still life to your satisfaction, spend some time experimenting with the angle of light in order to discover what lighting effects are possible. You will see that illumination from directly above can be bland, while side lighting is more dramatic. If you are using bottles or glassware as a still life, consider providing back lighting for your subject.

Whether you are using natural or artificial light, study how lighting illuminates, reflects and creates shadows. Capturing these effects in watercolour can be a fascinating study.

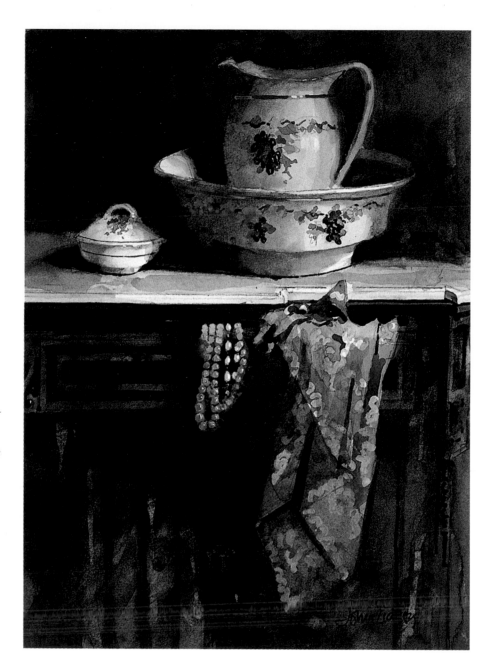

▲ Still Life with Jug and Scarf
46 × 30.5 cm (18 × 12 in)
This simple still life took a long time to set up. I tried out many other items to accompany the chinaware. Finally I chose the beads and scarf because they caught the light in an interesting way and provided a useful contrast in substance and texture.

Tips

● Look out for chinaware, jewellery and fabrics which can be used in still lifes. Attractive items can often be bought quite cheaply in antique shops.
● Sometimes direct sunlight can be too harsh for the illumination of an interior or still life. A piece of fine muslin pinned over the window space creates a much softer effect.

STILL LIFE WITH POPPIES

DEMONSTRATION

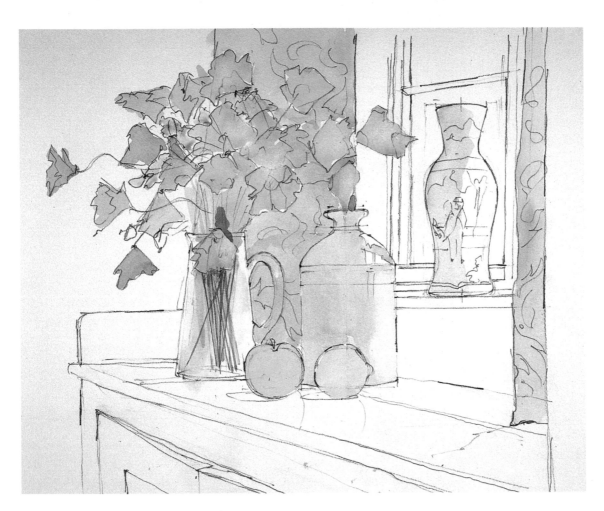

◀ *First stage*

This window space is a
favourite of mine for still lifes.
Beneath the window is a built-in
cupboard, the top of which gives
plenty of room for creating an
interesting arrangement. The
window faces south-west, so at
certain times of the year the sun
shines through it from midday to
the mid afternoon, with patches
of sunlight moving across the
subject during that period.

I completed this painting in
one session. It was a cloudy day,
so there were no problems with
shifting sunlight. However, even
the diffuse light I did have
differed in its qualities during
the course of the session.

What interests me here is the
interchange of lights and darks.
The flowers in light are set
against a dark background. The
stone vase picks up light from
the window and reflected light
from the jug. The glass jug also
catches the light, while the
shadowed side of the cupboard
provides an interesting base for
the subject matter.

COLOURS
French Ultramarine; Yellow
Ochre; Carmine; Indigo;
Permanent Red; Payne's Grey;
Aureolin; Cadmium Yellow Deep;
Scarlet Lake; Burnt Umber;
Prussian Blue; Permanent White
gouache.

FIRST STAGE
This painting was done on
300 gsm (140 lb) Waterford Hot
Pressed (HP) paper stretched
over hardboard. I first did a
preparatory drawing using a 4B

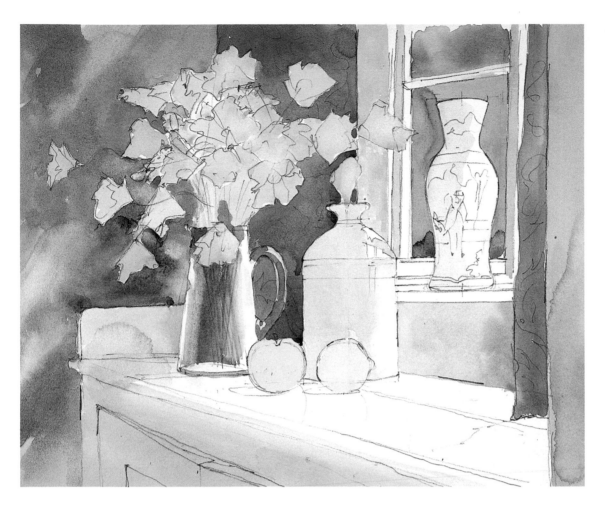

pencil, then began laying down very pale and pure washes over the principal elements in the painting, using mixtures from Yellow Ochre, Cadmium Yellow Deep, Carmine, Aureolin and French Ultramarine. I used a Series 66 mop brush for the washes and Series 40 Round brushes Nos 4, 6, 8 and 12 for the more detailed work.

SECOND STAGE
I wanted to bring out the contrast between the flowers and the wall and curtains behind them, so at this early stage I painted a concentrated wash of Permanent Red, Yellow Ochre and French Ultramarine for the curtains and Cadmium Yellow Deep and French Ultramarine for the wall. Notice how I have deliberately kept the washes quite loose in order to create an interesting surface texture to the paint. I used a No. 6 Round brush and painted round the flowers (reserving them). The cupboard top is the lightest part of the composition. Even so, I laid the palest of French Ultramarine washes over the entire surface of the cupboard with a stronger wash over the front in shadow.

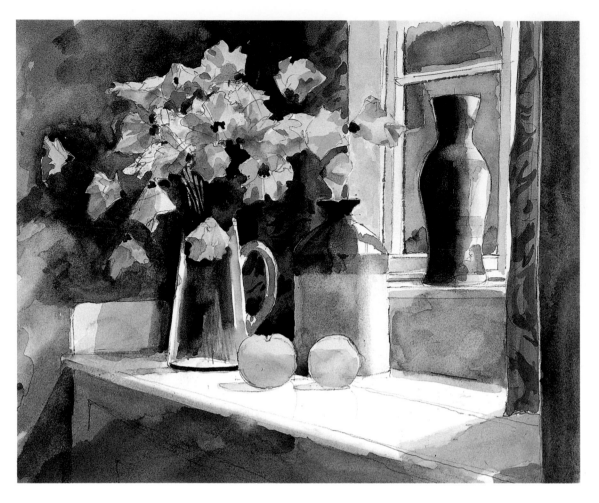

▲ *Third stage*

THIRD STAGE

I now began to develop some of the tonal values in the painting. The wall behind the flowers was further reinforced. I used a cold grey-green colour mixed from Indigo, Cadmium Yellow Deep and Payne's Grey to provide a contrast to the flowers. The shadow side of the curtains was overlaid with a wash of Scarlet Lake and Payne's Grey.

The vase on the windowsill needed to be very dark on its shadow side, so I built up its tone with a mix of French Ultramarine and Indigo. Notice how I have left the extreme edge of the vase unpainted because of the light reflected from the white woodwork of the window. The colour of the flowers was heightened with pure colours lightly brushed in.

FINISHED STAGE

To capture the effects of light and shade I further reinforced some of the dark tones in the painting, particularly behind the flowers, to make them stand out strongly. Some of the flowers are partly in shade. These I darkened, but only with pure colours in order to retain their overall brightness. The stalks were painted using Payne's Grey and white gouache.

In order to make the jug look sufficiently glass-like I noted the position of the highlights and left these unpainted, although I needed just a line of white gouache here and there to sharpen up the image. Some further work was also necessary to establish the shadow areas at the top of the jug around the flower. On the right-hand side I

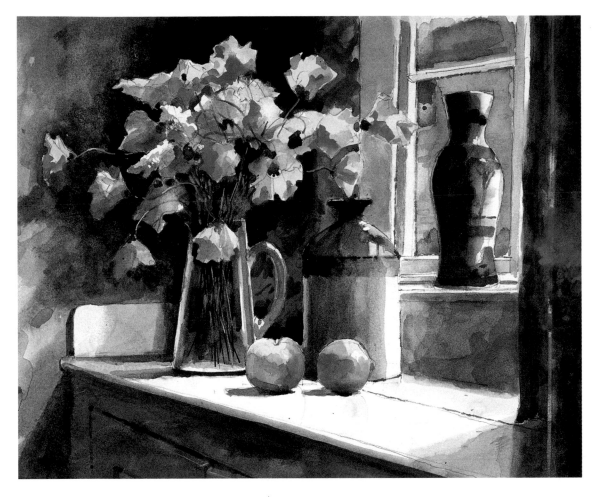

◄ *Finished stage*
Still Life with
Poppies
29 × 38 cm
(11½ × 15 in)

painted in the shadow of the curtain and intensified the shadow area of the wall. To prevent this part of the painting being too dominant I smudged the paintwork slightly with damp cotton wool and dropped in a highly concentrated mix of Cadmium Yellow Deep and Permanent Red which echoed colour in the flowers on the left.

DETAIL

This stone jar catches the light from the window. I have painted the lower half in shadow with a mix of Burnt Umber and French Ultramarine, leaving a thin strip of highlight which is a reflection of the glass jug. The darker areas of the upper half are painted in Indigo and Scarlet Lake. The highlights on the top right are reserved, but I have

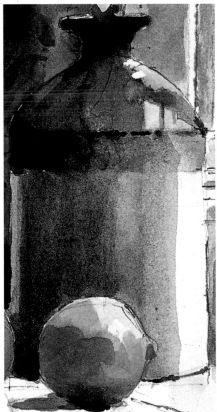

◄ *Detail*

added a brighter highlight using white gouache. The items of fruit and the yellow flowers make an interesting tonal contrast with the shadows on the jar.

This detail shows how I have used the paint quite freely to create an overall painterly quality to the work. Paintings which make use of a rigid, detailed technique can often look stilted.

LIGHT IN INTERIORS

Watercolour is traditionally associated with paintings of outdoor scenes, especially rivers, fields, mountains, lakes and so on. Certainly the majority of watercolourists seem to be magnetically drawn towards such themes. However, there are good reasons why it might be worth while turning to another subject to paint: interiors.

Watercolour is a medium ideally suited to this kind of work. Its pigments perfectly describe the delicate colours of fabrics, the luminosity of light through glass and the lustre of polished surfaces, and if used boldly they are capable of rendering dramatic contrasts of light and shade.

MAKING A BEGINNING

If you wish to try your hand at an interior the best place to begin is probably in your home – at least your own environment will be well known to you and everything you need will be conveniently to hand. Hallways, kitchens, bathrooms, even cellars can make good subject matter, especially if the lighting is right. It is a useful idea to study such areas at various times during the day – a setting which may look just dull in the morning can be ablaze with light in the afternoon.

When you are looking for a room setting in daylight, study the lights and darks carefully. You may for example notice that light on a wall surface changes subtly from one part of the wall to another, or that because it can reflect light a wooden table may be of a surprisingly bright tone. Additionally, many interiors contain objects with hard, reflective forms which create highlights. It is often these glittering bits of light that can be so good to paint in watercolour.

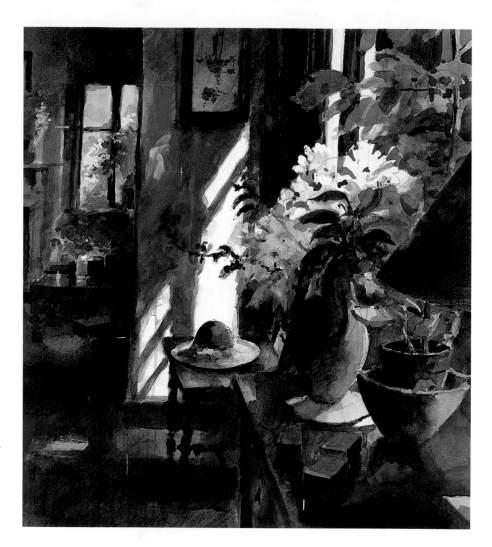

▲ Sitting Room at The Dell
43 × 34 cm (17 × 13½ in)
At 11am during sunny days in the summer this south-east-facing room begins to catch the sun. By 12.30pm the sun has gone altogether. This painting was produced during this brief time over a period of days. Before painting I rapidly sketched the subject to note the sunlight in the position I wanted.

MAKING ADJUSTMENTS

Often it becomes necessary to make a number of minor alterations to a setting in order to create a scene suitable for a painting. Even a very slight modification can often transform an unpromising subject into an extremely paintable one; for example, leaving a door open rather than closed or pulling back a curtain more than is usual can have a pronounced effect on interior illumination. Spreading a white tablecloth over a dark table surface can sometimes provide a dramatic tonal contrast just where it is needed, while an ordinary wooden chair can often be made to look lighter and more interesting simply by draping a pale-coloured coat or other garment over the back.

Do not try to fill all dark areas of your subject with light. You will probably find that certain spaces will be naturally dark, such as the underparts of tables and chairs. Keep these areas dark and allow them to provide a contrast with the lighter parts of your setting.

NATURAL AND ARTIFICIAL LIGHT

Splendid watercolours can be painted from a room setting lit either by daylight or artificial light. Under some circumstances it might seem tempting to combine both of these light forms when painting an interior, but in many cases this will not work satisfactorily as shadows will be cast in more than one direction. In general it is best to have a lighting arrangement which is as natural as possible.

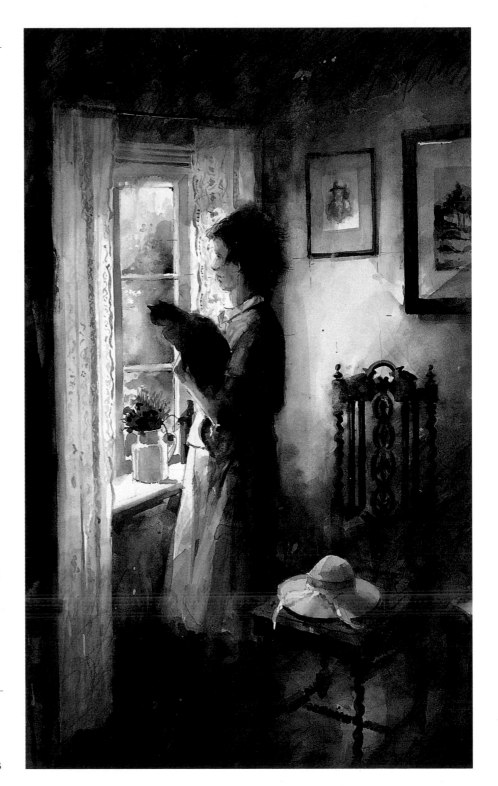

▲ Woman with a Cat
61 × 41 cm (24 × 16 in)
The light from this north-facing window is soft and even, but the area above and below the window is in deep shadow. The wall above the chair is the brightest part of the composition and throws the back of the figure into sharp relief. I placed the hat on the chair to introduce a light tone in an area of shadow.

47

ANNA'S ROOM
DEMONSTRATION

I have painted this corner of Anna's room on a number of occasions and on each one the quality of the light coming from the window has been different. The time of day, the season and the weather conditions have always created changed lighting conditions.

On this occasion the session took place over two afternoons in early summer. The sky was cloudy on both days, which meant that I had no problems with direct sunshine entering the room.

This angle of view provides a very interesting interchange of light and shade with some unexpected effects. The pale-coloured wall in shadow is much darker than the mahogany chest of drawers in the light, while the window, although it is the source of light, is slightly darker than the foreground bedspread.

I was concerned to give the room an informal look and to this end I showed a discarded shirt draped over the chairback, a used envelope propped up on the chest of drawers and rumpled bedcovers. These items also catch the light, bringing interest to the scene.

COLOURS
French Ultramarine; Cadmium Yellow Deep; Aureolin; Cadmium Red; Yellow Ochre; Payne's Grey; Indigo; Carmine; Monestial Blue; Permanent White gouache.

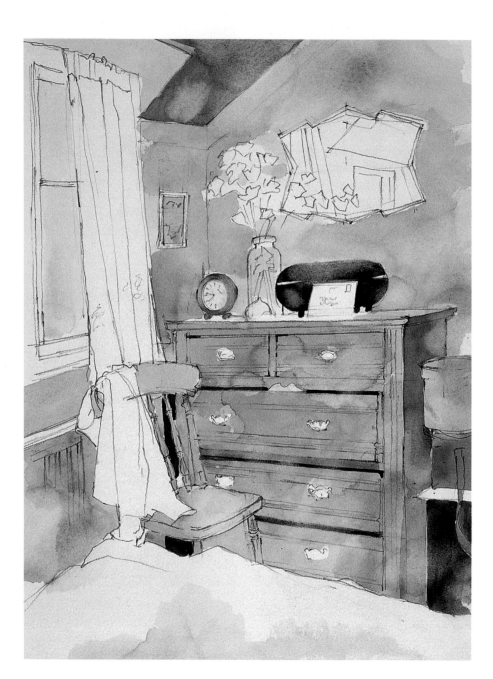

FIRST STAGE
The paper used here was 300 gsm (140 lb) Waterford Hot Pressed (HP) paper stretched over hardboard, and the paint was applied with Series 40 Round brushes in sizes 4, 8, and 12. With the No. 12 brush, I first laid in loose and wet washes of colour on the principal areas of the paintings. Between each application I made sure that the

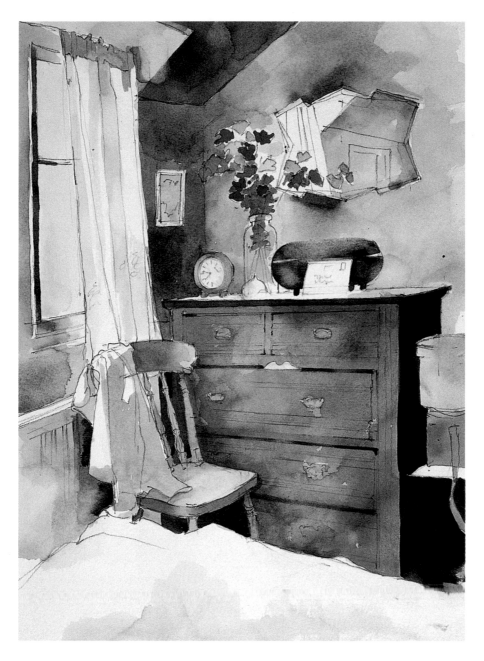

◀ *First stage*

painting was completely dry. I
used French Ultramarine for the
ceiling and Cadmium Yellow
Deep, Aureolin and French
Ultramarine for the wall. For
the chest of drawers I used
Cadmium Red, Yellow Ochre and
French Ultramarine. Finally, the
chair was given a weak wash of
Yellow Ochre.

SECOND STAGE
I wanted to quickly establish
some strong tonal contrasts in
the painting, so I overpainted the
side of the chest of drawers in a
strong mixture of Cadmium Red,
Payne's Grey and Yellow Ochre.
The shadow behind the shirt
was painted in a mixture of
Indigo and Payne's Grey.

Because I wanted to make the
poppies stand out strongly from
the background I began the
process of darkening the left-
hand wall. The colour used for

this was mixed from Aureolin,
Indigo and Yellow Ochre. The
overpainting on the front of the
chest of drawers was kept very
loose. To catch the uneven
quality of light I used the same
colours as in the first stage but
in a more concentrated form.
The colour was then washed out
in parts while wet using damp
cotton wool.

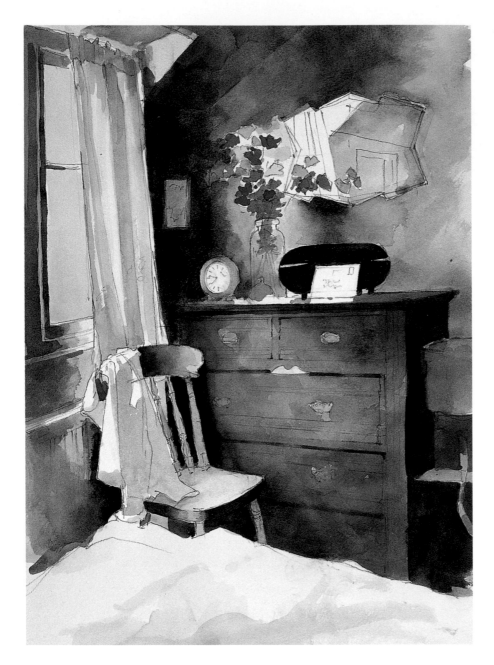

THIRD STAGE
You can see from the way the painting is progressing that my method of working is not to finish the painting of one item before moving on to begin the next. Rather, I develop the painting as a whole, studying the relationship of one part of the subject to another as I go. At this stage, however, I paid little attention to the mirror above the chest of drawers as I wanted to work out the tonal values in the room as a whole first.

The light falls away towards the bottom of the chest of drawers. Using the same colours as before, I began to darken this area further.

FINISHED STAGE
In order to achieve the effect of illumination it is often useful to exaggerate somewhat the lights and darks that are present in the subject. Here both the foreground and window radiated light, the strength of which I wanted to suggest in my finished watercolour. Therefore I further darkened the left-hand wall using weak mixes of Payne's Grey and Indigo and then applied similar treatment to the areas around the bedcover, using washes of Payne's Grey only. In both cases I allowed some of the underpainting to show through so that these areas did not become deadened.

When I painted the mirror I reserved most of the highlights but on other items, for example the handles on the chest of

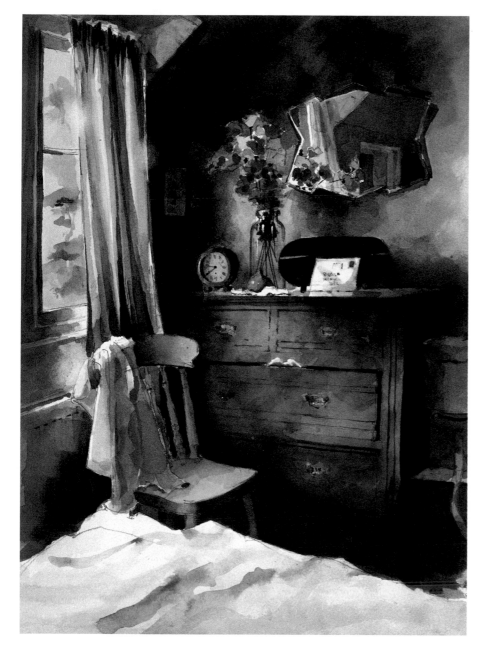

▲ *Detail*

drawers, the highlights were painted with discreet amounts of white gouache.

DETAIL

The poppies were painted in with a mixture of Cadmium Red and Carmine. I kept these colours as clean as possible in order to make them stand out strongly and appear bright.

Many watercolourists find that they experience difficulty in painting clear glass, but it is in fact a good deal easier to do than it may at first seem. The glass jar in this watercolour is suggested by a soft line defining its shape. Inside the line I have painted a soft area of tone which suggests the curvature of the jar. Four small highlights of white gouache complete the impression. It is common for beginners to make the mistake of painting clear glass in an overall darker tone than its surroundings, but this only has the effect of making the glass look slightly opaque.

▲ *Detail*

LIGHT IN LANDSCAPES

◀ Sketchbook study
This is a sky study made on holiday in a pocket sketchbook. I was particularly interested in the quality of light in the sky and recorded it from a car window.

It might be thought that landscape subjects offer only a few opportunities to paint the effects of light, yet it is possible to find excellent possibilities if you choose the right time, place and conditions.

PAINTING DURING WINTER

Although the light in winter can be beautiful, weather conditions often make it impracticable to paint for extended periods of time. However, interesting lighting conditions are not always accompanied by zero temperatures and sometimes you can work in a sketchbook even though it might be too cold to produce a complete painting.

If you work frequently, quickly and freely you may find that your sketches will begin to achieve an intensity and freedom you never thought possible, and with time some of these qualities will begin to feed through into your finished paintings.

Nonetheless, you may prefer to produce your watercolours directly from nature. Although

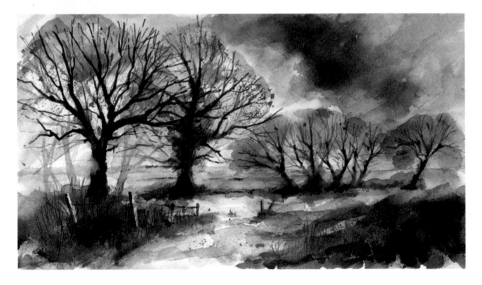

▲ In the Waveney Valley
16.5 × 33 cm (6½ × 13 in)
This is a favourite area of mine for sketching. The flat landscape and big sky provide me with marvellous opportunities for catching the effects of outdoor light.

with practice it is possible to produce highly realistic winter subjects from just sketches and accompanying notes, many watercolourists believe that their work will be more true to the subject if done there and then.

If you do paint on location you will often find that poor weather and quickly changing light will oblige you to keep your painting time short. It is important therefore that you try to capture the essence of what you are painting. Above all, be bold and remember to exclude unnecessary detail.

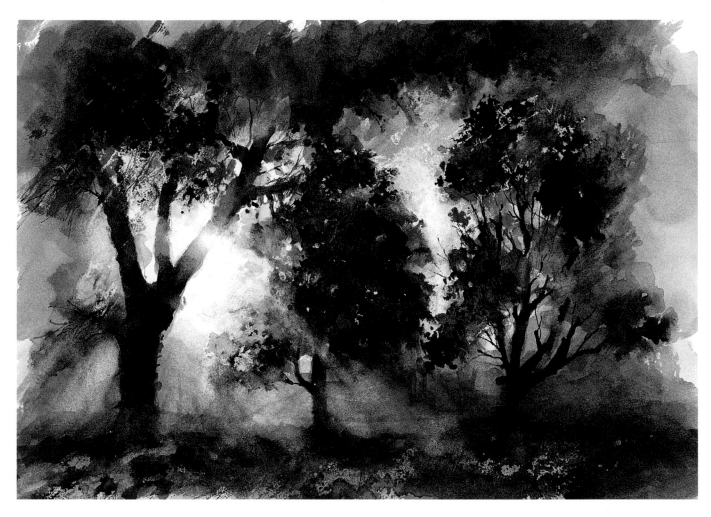

PAINTING IN SUMMER

Morning and evening are very good times for painting; the sun is low, the shadows are long and the colours can often be unusual. However, even at midday you can find unexpected lighting conditions. Trees can create interesting patterns of light and shade. If you look through them towards the sun, foliage can appear as a luminous green while trunks and branches are in dark silhouette.

In stormy conditions the combination of sun and clouds can transform a quite ordinary scene into one of breathtaking brilliance. Summer can offer you much brighter hues and lighter tones, and you will often be surprised by the colours in a landscape. Under strong sun, grass can sometimes look yellow or even orange. Rather than 'correcting' your impressions, paint the colours you see. Doing this will give truth to your watercolours and make them much more interesting.

While it can be good to paint in strong sunlight, extended exposure to the sun's rays can be an uncomfortable experience. It is best to paint in the shade if possible as this will not only afford you protection, it will eliminate the glare from white paper which often accompanies painting in full sunlight. In the shade you will find it easier to match your colours to those in the subject, and to make judgements about the lightness or darkness of colours.

▲ Trees Against the Light
35.5 × 38 cm (14 × 15 in)
This painting was based on a black and white photograph. I liked the way the camera had distinctly captured the effect of light. The colours were made up and I altered some of the features of the scene. Working from photographs is not a usual practice of mine but this one provided very good subject matter.

A FIELD IN LATE SUMMER
DEMONSTRATION

This watercolour is of a field which is normally used for grazing cattle. Although I have driven and walked past it on many occasions, this was the first time I considered it as a subject for a painting. The weather for the painting was fine. It was mid September and the foliage on the trees was just beginning to change colour. I exaggerated the yellows and yellow/greens in the subject to enhance the light and the sense of well-being in the scene; using colour to describe your own feeling about a subject is a major part of this kind of painting.

The composition of the finished watercolour is simple. A gate and hedge lead in from the right towards three trees; the hedge continues on round to link up with a smaller tree on the left. Nettles and weeds in the foreground together with an area of shade provide a base to the painting.

COLOURS
Cobalt Green; Rowney Vermilion; Cobalt Blue; Gamboge (Hue); French Ultramarine; Coeruleum; Aureolin; Carmine; Indigo; Lemon Yellow; Yellow Ochre; Permanent Red; Payne's Grey.

FIRST STAGE
I used my favourite paper for this painting: 300 gsm (140 lb) Waterford Hot Pressed (HP) stretched on to hardboard. The drawing was done with a 4B pencil and washes were laid in

▼ *First stage*

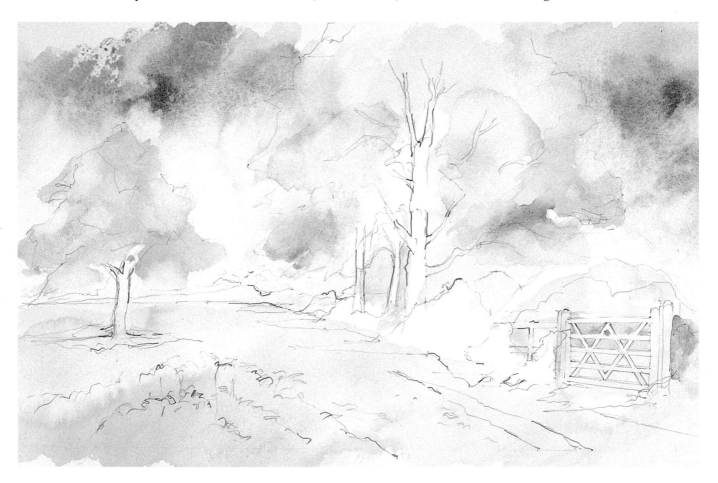

with a 12 mm (½in) wash brush. More detailed work was put in with Series 40 Nos 4, 6 and 8 Round brushes. I also made use of an old schoolroom dip pen for fine linear work.

I began the painting by first laying wet washes for the sky, using French Ultramarine and Yellow Ochre. You can see how the paint has granulated on the right-hand side. I find that this particular characteristic of French Ultramarine is wonderful for suggesting the qualities of a hazy sky.

The fields were then washed in, using a weak dilution of Lemon Yellow and Gamboge (Hue). For the trees I used Cobalt Green and Lemon Yellow. I was careful to allow the paint to dry between applications in order to avoid the possibility of one colour running into another.

SECOND STAGE

I painted in the tree trunks with mixes made from Yellow Ochre, French Ultramarine, Rowney Vermilion and Payne's Grey. To create a sense of distance and shade the hedges were painted in blues rather than green (French Ultramarine and Indigo). The foliage of the two trees was given darker and more intense washes of colour in Cobalt Green and Gamboge (Hue). I dropped water into these mixes to encourage the colours to run in together.

The sun shone from the right-hand side and was very bright. This created quite dark directional shadows to the left of the trees. Because I wanted them to be soft-edged I began their painting with pale washes of colour, planning to intensify them later.

I began painting the foreground clump of weeds and nettles using a mixture of Cobalt Green, Rowney Vermilion and Yellow Ochre.

▼ *Second stage*

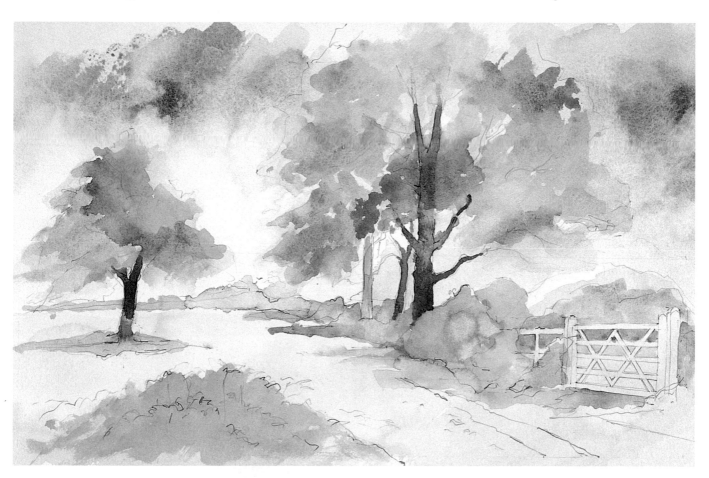

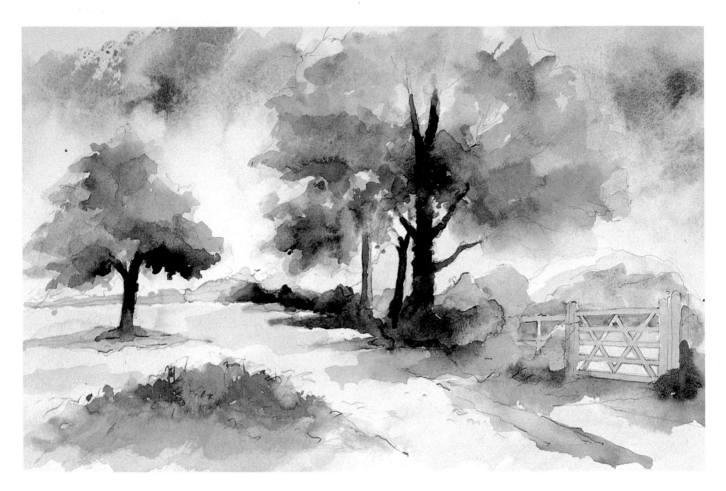

THIRD STAGE

The tree on the right of the painting required more attention now. I was concerned to create patches of watercolour which would suggest a complicated pattern of foliage. To do this I puddled paint on to the paper using mixes from Gamboge (Hue), Lemon Yellow, Cobalt Green, Permanent Red, Indigo and Cobalt Blue. While these colours were drying I treated the left-hand tree in a similar fashion but kept the colour patches simpler and less sharply defined.

In addition to work on the trees I began to develop the painting around the area of the gate and darkened the foliage in the background using mixes of Cobalt Green and Gamboge (Hue) in various strengths. I also darkened the ground immediately in front of the gate using low-toned brown mixed from Yellow Ochre, Permanent Red and French Ultramarine. I avoided painting too much detail in these areas, wishing to focus the viewer's attention on the large tree towards the centre of the painting.

▲ *Third stage*

56

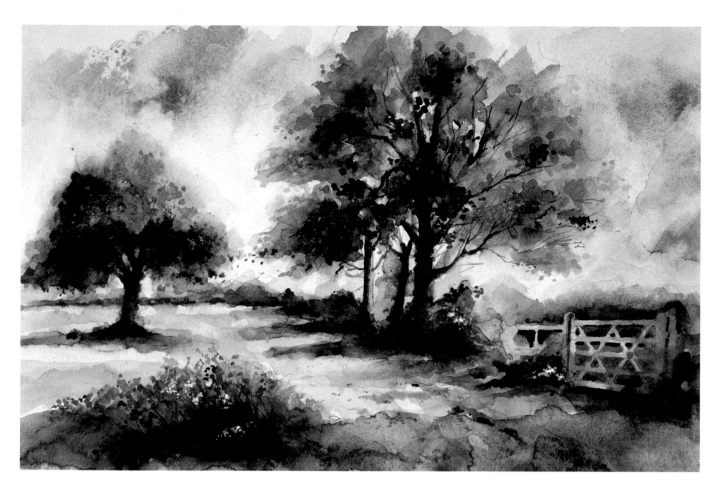

FINISHED STAGE

I completed the foreground weeds with a No. 4 brush and my dip pen. Over-descriptive painting in this corner would have been distracting, so I kept the detail soft and diffuse. I darkened the base of this mass with Rowney Vermilion and Indigo. Parts of the gate were then darkened using a flat wash of French Ultramarine and Yellow Ochre.

The shadows under the trees were darkened by laying in further amounts of colour, mainly Indigo and mixes of Rowney Vermilion with Indigo. Some minor branches were added to the right-hand tree with a small brush and my handy dip pen. Also, to increase the impression of depth in the foliage, I added extra patches of dark leaves in shadow.

It rather concerned me that the pale tones of the field were draining out of the bottom of the painting. To overcome this effect I decided to lay a wash of French Ultramarine and Yellow Ochre over the foreground. I think this benefited the composition. Towards the end of a painting it is important to look at the completed work and to assess its effect quite independently of the subject matter. Sometimes carrying out even a very minor alteration such as this will make the watercolour work much more successfully.

DETAIL

The foliage was built up by using numerous layers of watercolour, wet-on-dry. The tonal strength of the colours was gradually increased as the painting progressed.

▲ *Finished stage*
A Field in Late Summer
28 × 46 cm (11 × 18 in)

▲ *Detail*

LIGHT IN CITIES

Buildings and city streets in sunlight can be a splendid subject for the watercolourist, but very good paintings can be inspired by other kinds of light too. For example, illumination from neon signs, shop windows and street lighting can provide outstanding opportunities for picture-making, while at dusk, when street lighting is beginning to take over from the setting sun, a mysterious half-light can come into being.

Light, or in some cases the lack of it, can create a mood which the painter can exploit. A scene which at midday might look quite ordinary can be transformed by a change in lighting conditions, so if you have found what looks like an interesting subject check to see how it appears at various times of the day. The extra effort you put in here might result in a much better painting.

◀ Shopping in Norwich
38 × 23 cm (15 × 9 in)
This busy street is packed with detail but I have simplified much of it in my painting. I have concentrated on the lights and darks in the subject. The church tower is a low-toned and dominant feature of the scene but I have lightened it to avoid the claustrophobic effect it might otherwise have.

ARTISTS' LICENCE

It is not necessary for your painting to be a photographic representation of what you see; you can modify or exaggerate the lighting in your painting to create a certain type of mood.

Intensifying the contrast of light and shade can produce brilliant or dramatic effects which might be suitable for modern architecture or even sculpture in public places.

Alternatively, lowering the tonal values of both light and shade can create softer, more melancholic qualities possibly suitable for old buildings or decaying houses and factories in the more deprived parts of town.

POSSIBILITIES OF LIGHT

Lighting can actually be the subject of your painting. You may want to paint sunlight reflected in a window or even the shadows cast by railings on a pavement.

In some cases the sun itself can be featured in a painting. If you paint from a high vantage point it might be possible to produce a splendid watercolour of the sun set low in the sky, throwing outlines of commercial buildings, churches, spires and domes into sharp relief.

Look for the interesting lighting conditions created by

the changing seasons. In winter, for example, the city can look black and bleak when lit by a weak sun, but traffic lights, illuminated road signs and shops can change the mood to one of greater warmth and intimacy.

A single lit window of a house, painted from the outside at night, can also offer a wonderful subject for the watercolourist. Such opportunities for painting light exist everywhere in cities.

PAINTING IN BAD WEATHER

In most cases painting outside in winter is uncomfortable or downright impossible. You may feel that a few sketches could be made before the cold becomes too much to bear, but in extreme conditions even this might be impracticable. The best solution is to paint from a building where you can be sheltered from the elements. Many artists have painted from an upstairs window, recording street scenes or views across rooftops.

As an alternative, you can take photographs of interesting lighting conditions during bad weather and then paint your watercolour using a colour print or a transparency as a reference. This is a very popular way of working, but if you wish to develop your skills you should take as many opportunities as possible to paint from the subject as you see it.

▼ The City, Looking West
28.5 × 44 cm (11¼ × 17¼ in)
In painting this watercolour I was interested in the building styles sandwiched together with no apparent unity. The old railway viaduct with the more modern architecture in the distance creates a good contrast. The light was good and the absence of haze and traffic fog made the details of the buildings crystal clear.

THE GUIDED TOUR
DEMONSTRATION

In many towns sightseers gather outside buildings and other points of interest. Often they are part of a guided tour. This painting shows a typical group standing outside a brightly illuminated bar.

The subject attracted me because of the many sources of illumination. Night-time street scenes are often poorly lit, but here the subject was ablaze with light. Even the illuminated upper windows bring interest to the that part of the building. The tourists' faces reflect light from inside the bar, while their legs and feet are left in shadow. A lamp shines in the side entrance, dimly lighting the way to another bar at the back of the building.

I decided I would keep the brushwork free and loose to create a sense of movement. I applied the paint in a heavily diluted form, creating an extremely wet paper surface. On occasions I flooded concentrated mixes of colour into this wet paint to create the marks that are so characteristic of watercolour.

COLOURS
French Ultramarine; Prussian Blue; Payne's Grey; Indigo; Burnt Umber; Cadmium Yellow Deep; Aureolin; Carmine; Permanent Red; Yellow Ochre.

FIRST STAGE
The painting was done on 300 gsm (140 lb) Waterford Hot Pressed (HP) paper stretched

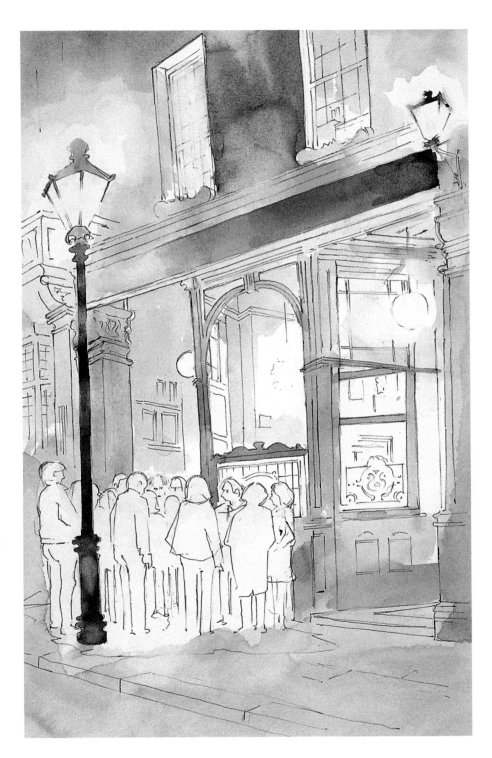

▲ *First stage*

60

over hardboard. I made a preparatory drawing with a 4B pencil, then used a Series 66 mop brush for washes and Series 40 Round brushes in sizes 2, 4, 6 and 8 to apply more detailed work.

First I painted down weak washes of watercolour to establish the principal hues for the painting. Around the upstairs windows I brushed in cool blues and violets with Carmine and French Ultramarine. I used a very weak Yellow Ochre around the street lights, keeping the paint well away from the glass of the lamps. The woodwork on the front of the building was painted in thin mixtures of Indigo and Prussian Blue.

I wanted to create a strong colour contrast between the building itself and the pavement in front, so I began by painting this area in Yellow Ochre with just the smallest amount of Permanent Red added. As you can see, all the colours were applied extremely wet so that backruns, or cauliflowers, occurred. Because most of these were painted over in later stages they do not appear in the finished painting.

SECOND STAGE

Starting at the very top of the painting, I began to neutralize and deepen the tonal strength of the colours a little. This was done by using less water in the mixes and by adding Payne's Grey to the colours.

The interior of the bar seemed to be too yellow, so I brushed in a very weak wash of pure Permanent Red over the top of the Yellow Ochre already painted. I also made a start on the figures, painting with simple colour washes.

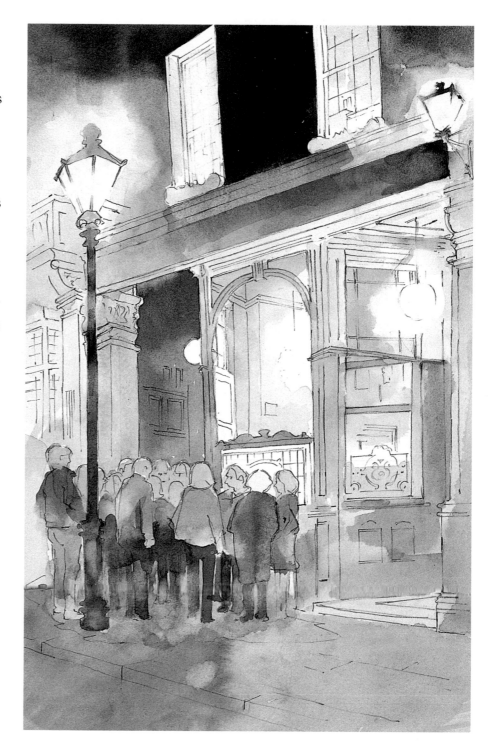

▲ *Second stage*

61

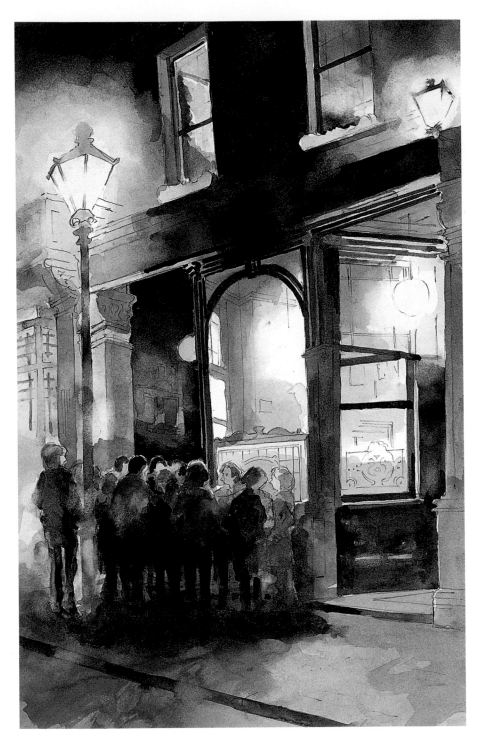

▲ *Third stage*

THIRD STAGE

So that I could suggest the quality of the light, I began to darken the tones both on the exterior of the building and in the foreground considerably. Notice how I have kept the watercolour very free and loose, building up the colour with successive washes.

Dark shadows were painted under the tourists' feet to develop further the sense of overhead lighting. For these I used Payne's Grey mixed with Indigo. I don't normally employ these colours for shadows, but in this case I wanted to create a really murky blackness.

FINISHED STAGE

The painting was by now well on the way to completion, but it was still necessary to add detailing and deepen the tones even further. My mixes of colour were now quite concentrated, the pigment being of a thick, almost soupy consistency. You can see how I have darkened the area around the lamps and above the illuminated central window. The immediate foreground has been overpainted too, using Payne's Grey and Permanent Red.

The majority of the washes were painted using a No. 6 Round brush, smaller than the one that I usually employ. I wanted to avoid the effect of smooth, even washes, preferring in this case to achieve a more scrubbed and textured effect. The detailing was added with a No. 2 Round brush.

I have in one or two places used just a little white gouache for the highlights. It is important to remember that too much of this treatment can spoil the finished result.

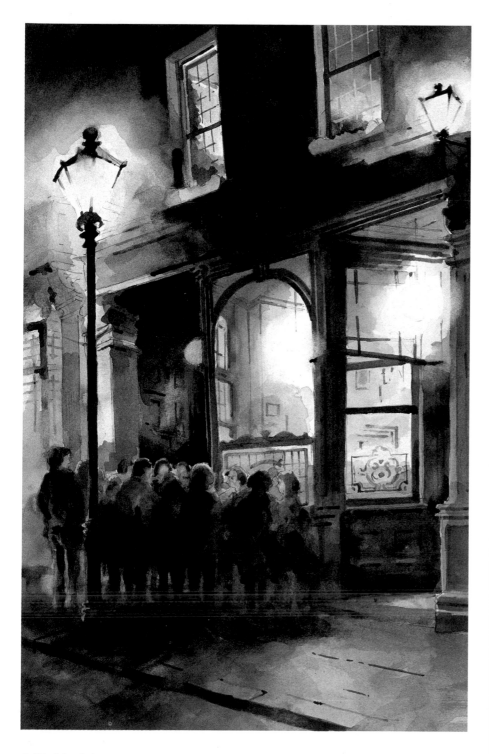

▲ *Finished stage*
The Guided
Tour
47.5 × 30.5 cm
(18¾ × 12 in)

DETAIL
The light inside the bar was supplied by a round illuminated globe. I have avoided exactly defining its shape so as to give the light an incandescent quality. The paper here has been left unpainted; all I have shown is the flex from which the light is suspended. Having brushed in colour surrounding the light I mopped out excess amounts with damp cotton wool, and when the paint was dry I further softened it by gently rubbing with more cotton wool and clean water. Notice how I have removed some of the watercolour on the exterior woodwork in order to suggest the effect of reflected light here.

▲ *Detail*

AND FINALLY

Go to commercial art galleries and national collections as often as you can to study the work of watercolourists who have used light as a feature in their paintings. Take time to analyse their methods and experiment with their techniques in your own paintings.

Keep a sketchbook and use it as often as you are able to. Note down anything that appeals to you, no matter how roughly. By doing this you will be developing your abilities to work quickly and freely.

If you want to explore painting light further, you should compile a scrapbook of anything relevant to the subject. Such a book could contain photographs, reproductions of paintings, cut-outs from gallery catalogues and so on, together with your own notes. Its accumulated contents could well supply answers to your watercolour problems in the future.

Above all, persevere with your watercolours. Rewards will come from constant practice, so paint as often as you can – every day, if possible. Your technique will develop and your powers of observation will greatly improve.

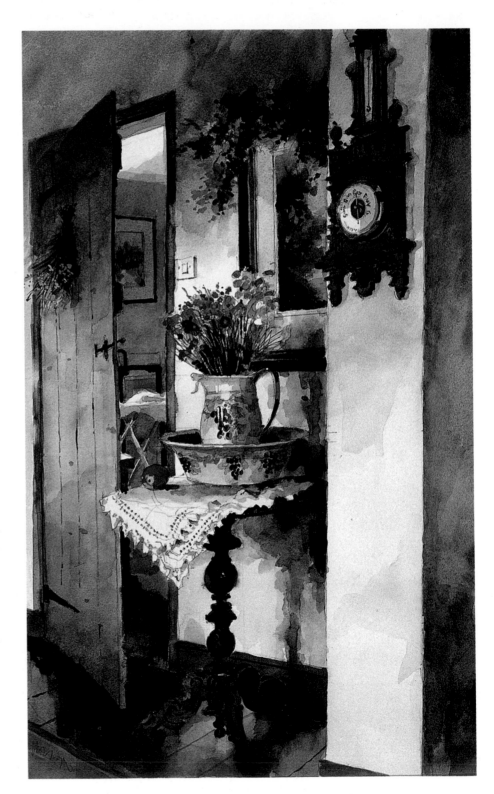

▶ A View through the Door
53.5 × 32 cm (21 × 12½ in)
This is a favourite subject of mine. The pale walls and the dark shadows on the floor make very interesting tonal contrasts.